ARCHITECTURAL PHOTOGRAPHY THE DIGITAL WAY

ARCHITECTURAL PHOTOGRAPHY
THE DIGITAL WAY

GERRY KOPELOW

PRINCETON
ARCHITECTURAL
PRESS

PUBLISHED BY
Princeton Architectural Press
37 East Seventh Street
New York, New York 10003

For a free catalog of books, call 1.800.722.6657.
Visit our website at www.papress.com.

EDITING
Nicola Bednarek

DESIGN
Andy Pressman / 212box

TYPEFACES
Kievit family, designed by Mike Abbink

SPECIAL THANKS TO
Nettie Aljian, Dorothy Ball, Janet Behning,
Becca Casbon, Penny (Yuen Pik) Chu, Russell Fernandez,
Peter Fitzgerald, Wendy Fuller, Jan Haux, Clare Jacobson,
John King, Nancy Eklund Later, Linda Lee, Katharine Myers,
Lauren Nelson Packard, Jennifer Thompson, Paul Wagner,
Joseph Weston, and Deb Wood of Princeton
Architectural Press —Kevin C. Lippert, publisher

Library of Congress Cataloging-in-Publication Data
Kopelow, Gerry, 1949–
Architectural photography the digital way / Gerry Kopelow.
 p. cm.
 Includes index.
ISBN-13: 978-1-56898-697-5 (alk. paper)
ISBN-10: 1-56898-697-1 (alk. paper)
1. Architectural photography.
2. Photography—Digital techniques. I. Title.
TR659.K657 2007
778.9'4—dc22
 2007004345

For my terrific children, Sacha and Leo, artists both.

CONTENTS

INTRODUCTION

As this is being written, it has been more than three years since I last made a commercial image on film. All my painstakingly accumulated large-format, medium-format, and 35-mm film gear is gone because today I shoot exclusively with high-end digital equipment. I am able to carry my entire complement of cameras and lenses over my shoulder, while the rest of my kit, consisting of a modest electronic flash set-up and a tripod, fits easily into a small roller case. The digital revolution is a great liberation. But the wide variety of photo-related digital hardware and software available today can be overwhelming. And of course, the technical revolution has engendered a revolution in shooting and lighting methodologies to match.

The proliferation of design-oriented magazines, desktop publishing, digital imaging, and websites has made well-executed architectural photography ever more important for design professionals. Today all architectural practitioners need to know how to produce high-quality images in order to document, publish, and market their projects. When premium results are required, the first and often the best resource is a professional architectural photographer. While professional photography is expensive, the marketing benefits will usually justify the cost. Nevertheless, establishing an extensive image archive is a slow business, and a return on investment can be a long time coming. The question arises: How can a range of utilitarian and sophisticated photographic needs be satisfied without breaking the bank? The answer is simple—do the work in-house. Of course, an amateur will never be able to compete with a professional all the time, but a well-prepared amateur using a digital single-lens-reflex camera can produce respectable results. This book will teach you how to take successful photos of buildings, inside and out, with digital equipment. Step by step you will learn how to choose the right kind of camera, how to use it effectively, and how to enhance and manipulate your images digitally. As with most crafts, practice is everything, so happy shooting!

1 CAMERA BASICS

High-quality architectural photography fulfills the following characteristics: The image is clear, with an abundance of detail and consistent focus. Its color appears natural and appropriate for the scene. Perspective and point of view are natural and pleasing, and the sun angle, sky conditions, and seasonal variations are appropriate. The subject is portrayed in proper context relative to the site, and the scale of the subject is properly established. To understand how to

achieve these goals, we need to start with the fundamentals of digital photography.

A digital camera is a light-tight box that holds a lens and a light-sensitive electronic sensor in precise alignment. The lens projects an image of an object in the real world onto the sensor, which yields an encoded series of electrical potentials. After various mathematical manipulations the signal becomes an electronic analogue of the original optical image. The degree to which a sensor responds to a given amount of light is described by an ISO (International Standards Organization) rating. This system was originally established to quantify the characteristics of film, but today we can choose from a range of electronically selectable sensitivities. The higher the ISO, the greater the sensitivity—ISO 3200 is very high while ISO 50 is very low. The amount of light that is recorded by the camera has to be regulated to accommodate the characteristics of the sensor. This regulation is achieved with a shutter and a diaphragm.

The shutter is a door through which the light passes. Not too long ago shutters were governed by clockwork mechanisms to open and close automatically for short periods of time (about 1 second to 1/500th of a second) and operated manually for longer periods of time (about 2 to 300 seconds). Modern shutters operate electro-mechanically across a much wider range of precisely controlled intervals.

The diaphragm is a variable aperture, much like the iris of the human eye. The wider it is opened, the more light can pass through the lens. The size of the opening is calibrated in units called F-stops. F-stops are determined by the formula F=FL/A, where FL is the focal length of the lens (the distance from the center of a particular lens to the sensor plane, when the lens is focused on a distant object) and A is the diameter of the lens. Because the F-stop is a reciprocal, a relatively large number means a relatively small amount of light will be transmitted through the lens: F1.4 is considered large, whereas F22 is small.

The aperture setting and the shutter speed are inversely related: if the aperture is increased (widened), the shutter speed must be decreased (shortened in duration) and vice versa in order

A diaphragm set at three different F-stops: Wide open (left), moderately stopped down (center), and stopped down all the way (right).

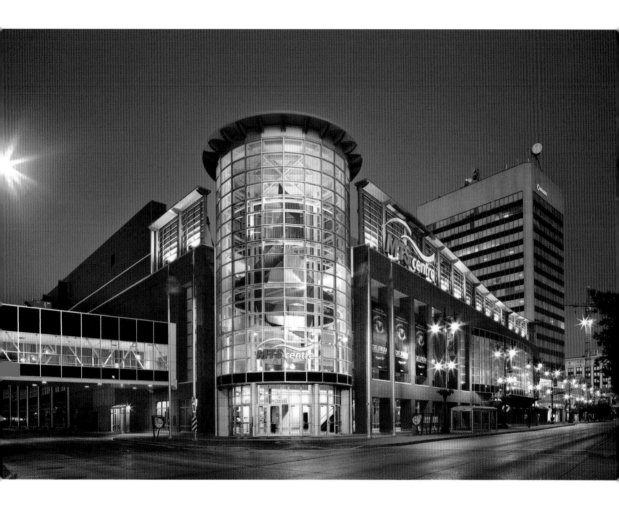

This image of the recently constructed arena in downtown Winnipeg is supported by a wealth of contextual information and many visual clues that quickly establish the scale of the project. The building's primary use, as a venue for large-scale entertainment events, is suggested by the richness of the interior and exterior colors, and further enhanced by the night-time view.

to maintain correct exposure. All digital cameras, of all formats, incorporate a lens, a diaphragm, a shutter, a sensor, and a light-tight box to hold them together.

1—1 CAMERA TYPES

Architectural photographers need a basic understanding of two camera types: the large-format view camera and the single-lens-reflex (SLR). The view camera has been around since photography began while the SLR is a relatively modern creation. View cameras originally used sensitized glass plates, but today the standard is 4x5-inch sheet film. The small-format SLR was originally designed around 35-mm roll-film. Both systems have been adapted for digital capture and both offer a range of technical choices; what these choices are and how they facilitate the photography of buildings deserves some study.

The view camera projects an upside-down, reversed, left-to-right image onto the ground-glass focusing screen. When a wide-angle lens is used, the resulting image is dark and exhibits significant fall-off in brightness at the edges, making accurate focus difficult.

1—2 VIEW-CAMERA BASICS

Most small- and medium-format cameras are rigidly constructed so that the lens and the sensor plane are held in precise alignment; they may not always be the same distance apart, but in all conventional cameras a line drawn through the exact middle of the lens will always be located perfectly perpendicular to the image plane and always in a position that is perfectly centered within the image area. In view cameras, on the other hand, the alignment between the lens and the image plane is not fixed but can be adjusted. These adjustments (or movements) make the view camera a powerful and versatile tool.

Camera movements have two functions: control of perspective distortion and focus control. The movement called "front rise" is the most useful one for architectural photography. Ordinarily, if a camera is level and pointed at a tall subject such as a high-rise building, the top part of the subject will not be visible. Tilting the camera upward brings the whole building into view, but its vertical lines will appear to converge. Front-rise movement keeps the vertical lines of the subject parallel by allowing the camera to remain level. The upper part of the building is brought into view by a vertical displacement of the lens axis above the center of

The flexible bag bellows of this 4x5 view camera allows extreme horizontal and vertical movements.

the image plane (i.e. the lens is physically moved upward), rather than by tilting the camera. "Front fall" is used in a similar way when the subject extends below the field of view.

Front and rear "shifts" are horizontal displacements of the lens or the image plane. These controls allow very wide subjects to be accommodated in the same way that front rise and fall accommodate very tall subjects. Sometimes a dead-on rectilinear view cannot be achieved because the perfect camera position is blocked by an obstacle; in such circumstances shifting the lens and/or the rear standard will permit an off-center camera location while still maintaining perspective integrity. This is very useful for shooting architectural interiors. Bothersome reflections can often be eliminated in this way as well.

To focus the camera, the photographer views the reversed and inverted image that is projected on a ground-glass screen by the lens. The shutter must be open and the film or digital back removed so the image can be seen; a light-proof cloth is used to shade the ground glass. Unfortunately, the image is often dark and difficult to evaluate, particularly with wide-angle lenses. Once the photograph has been lined up and focused, the shutter is closed and the film or digital sensor repositioned to make an exposure.

Because of its technical sophistication, the view camera has been the tool of choice for professional architectural photographers for almost two centuries. Professionals cope with the long set-up times, the cost, and the physical burdens because the degree of image control offered by the view camera is at once subtle and magnificently effective.

1–3 SMALL-FORMAT BASICS

An SLR uses a hinged front-surfaced mirror to divert the image projected by the lens into the viewfinder. A prism in the finder presents a bright, right-side-up image at the camera's eyepiece. Because the image-taking lens is also the viewing lens, it is possible to preview exactly what will appear at the image plane, at least in terms of image composition. The mirror retracts out of the way during the exposure. Since the viewfinder system is bright

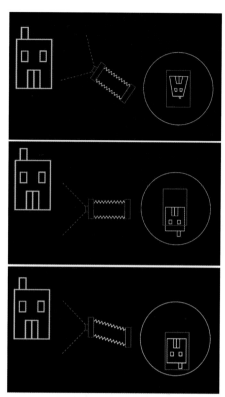

The top image shows what happens to the shape of a tall rectilinear subject when a camera is tilted up in order to capture the entire view. (The whole image circle that the lens is capable of projecting is marked by the green circle.) The middle image illustrates how rectilinearity is restored when the camera is leveled. However, part of the image is now outside of the film/sensor range and cannot be recorded. A front-rise movement brings the image of the subject back inside the sensor area (bottom image).

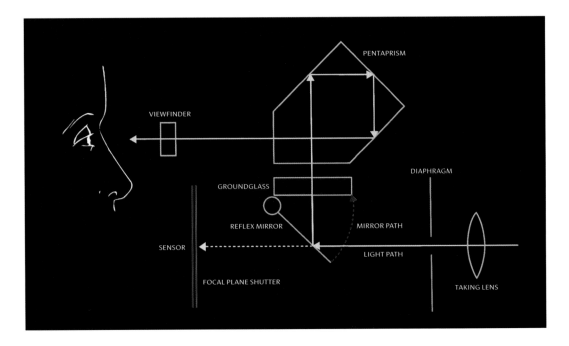

and accurate, SLR cameras are easy to use. Wide-angle, telephoto, and zoom lenses can be easily interchanged, and today's film and digital SLR cameras also offer a broad range of other features such as auto-focus and auto-exposure. Most critical for high-quality architectural work, however, are recent improvements in sensor performance and the availability of excellent interchangeable lenses.

The yellow arrows trace the light path through the geometry of an SLR digital camera.

1–4 MEDIUM-FORMAT BASICS

Medium-format cameras were originally developed to use 60-mm roll-film. They are hybrids that borrow technical features from both large and small formats. As is the case with 35-mm systems, the most popular medium-format configuration is the single-lens-reflex. Effortless interchangeability of lenses is again the major advantage, although interchangeability is extended to film backs (and lately, digital backs) and viewfinders. With an image area up to five times greater than the 35-mm SLR, medium-format images can be made sharper and more detailed. Unfortunately, a penalty

in bulk and weight must be paid in exchange. Only recently have medium-format systems evolved to the point where they are almost as fast to operate as their smaller counterparts. Prices for quality equipment are astronomical. Digital backs for large- and medium-format cameras start at around $10,000 and range upwards to $40,000.

1–5 SELECTING A FORMAT

Deciding on a working format is a trade-off between cost, image-making ability, and practicality. The view camera wins for technical virtuosity, while the SLR is unbeatable in terms of ease of operation and relatively low cost. The ultimate choice for architectural photographers is difficult to make, since view-camera movements are essential for many tricky shots. Nevertheless, two considerations tip the scales toward small format: the recent introduction of high-performance digital SLR (DSLR) cameras and the availability of perspective-control (PC), also known as tilt/shift (TS), lenses that mimic view-camera movements.

2 A DSLR PRIMER

Today's digital cameras are technologically advanced systems that can be tailored to suit a wide variety of photographic purposes. Much of what is offered is not necessary for our intentions; DSLR architectural photography requires only the most basic camera functions. The most valuable photomechanical aspects of the SLR design include a sturdy and precise construction, a built-in lightmeter that can be operated manually, a wide selection of

quality optics (including PC lenses), an electronically governed shutter with an extended slow-speed range, and a tripod socket.

Since the SLR design uses a moving mirror together with a fixed prism, a small ground-glass screen, and a fresnel lens for viewing and focusing, the positioning and stability of these components is critical. Precise and robust construction is necessary to achieve maximum image sharpness.

All modern SLRs have an in-built metering system that measures the light gathered by the lens. Because these meters see what the lens sees, they are called through-the-lens (TTL) or behind-the-lens (BTL) meters. BTL meters are satisfactory in most circumstances, provided they can be used in a non-automatic mode. The situations architectural photographers encounter are not the same as the scenes automatic exposure systems are programmed to cope with. If the auto-exposure system cannot be disabled when necessary, results will be poor.

Lens interchangeability is one of the most attractive features of DSLRs. All modern cameras use a bayonet-type mount with a spring-loaded latch/détent. Lens interchangeability is important because various kinds of lenses offer different kinds of photographic effects (see pages 24–33). Superior lenses are essential for good work.

The exposure times for many architectural images are long, ranging from half a second to sixty seconds. A camera that is capable of electronically timing such long exposures is therefore very convenient. Of course, it is impossible to hold a camera critically steady for such long exposures without a tripod.

2–1 EXPOSURE

Correct exposure depends on a few light-sensitive elements receiving just the right amount of stimulation. BTL meters measure light entering the camera through the taking lens, so all factors impacting the intensity of the light reaching the image plane, such as filters and lens transmittance, are automatically taken into account. The meter indicates how much light it sees, but no machine can interpret quantitative measurements in a way that will guarantee the appropriate exposure every time. This

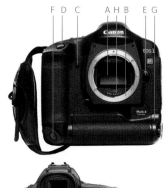

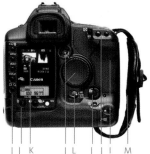
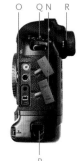

Shown here is a Canon 1DS MKII camera with interchangeable lens removed. The design of different-brand DSLRs differs but most high-end cameras offer similar controls and features.

A Reflex mirror
B Stainless-steel lens mount
C Emitter window for infra-red auto-focusing beam
D Horizontal shutter release button
E Lens release button
F Vertical shutter release
G Battery compartment
H Electronic contacts for lens/body communications
I CF card component
J Electronic function buttons/controls
K LCD panel with image previews, histogram, and data
L On/off switch
M Wrist strap
N Dust shield for electronics contacts
O Contacts for electronic cable release, camera-
 computer interface, flash synchronization
P Release latch for battery
Q Electronic function buttons/controls
R Viewfinder

The side view shows connectors for flash synch, cable release, and video output as well as digitals output via USB and Firewire.

decision is the responsibility of the photographer and it involves some thought.

IT'S A GRAY WORLD

Professional photographers often depend on a gray card—a standard neutral target of 18 percent reflectivity—to determine exposure. If a lightmeter is pointed at a gray card, the indicated exposure will result in a print that looks exactly like that target, as long as every step in the photographic process is consistent. Lightmeters are calibrated to the tonal value of a gray card, because all the tones in a typical scene, when randomly scrambled, will average out to the equivalent of 18 percent gray. Unfortunately, in the real world, such an approach is not always sufficiently flexible.

Consider the photographic implications of a man, standing in direct sunlight, wearing a white shirt and a black suit. A lightmeter pointed at this scene from the camera position might indicate F11 at 1/125 sec at an ISO setting of 100. If a closer reading is made from the shirt, the reading might be F22 at 1/250 sec. Another reading made from a shadow area on the dark suit might indicate F4 at 1/60 sec. A comparison of the two close-up readings indicates a span of eight F-stops. But most sensors are capable of recording a dynamic range of only six to seven stops. This means the shadow side of the man's suit will drop off the dark end of the spectrum and print jet-black while the sunlit white of the shirt will shoot over the top of the reproducible tonal scale and consequently print bald white. The human eye and brain working together can tolerate a brightness range of more than 1,000,000:1, which means that what we see in real life and what we see in a photograph will not necessarily coincide. Some skill is required to reconcile the eye/brain response to the photographic response.

Lightmeters should be considered brightness meters rather than exposure meters. Individual readings indicate specific intensities of light, but no single reading can be trusted as an overall exposure. Instead, the meter must be used to determine the relative brightness of the subject's significant tones (i.e. image contrast), and whether or not the tonal scale of the subject corresponds to the tonal range of the sensor. If the two are out of

A photographic gray card is a standardized target of uniform reflectivity and color used to determine correct exposure and neutral white balance.

This is a typical hand-held lightmeter. The white diffuser dome over the photocell sensor acts like a gray card, averaging the light falling on its surface.

 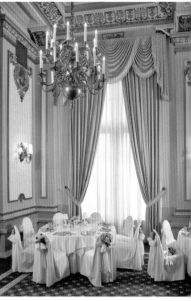

alignment, the photographer has to make a decision as to which tones in the subject are to be sacrificed.

THE HISTOGRAM

The creation of high-quality negatives and transparencies required close attention to lightmeter readings backed up by testing with Polaroid instant film—a time-consuming process that generated a pile of expensive, chemical-laden trash. The procedure for determining correct exposure in the digital realm is easier, faster, more accurate, and ecologically benign; The liquid crystal display (LCD) found on every digital camera is terrific for quick reviews of image composition, but the histogram is the ultimate tool for exposure evaluation.

A histogram is a graphical representation of the distribution of tones in a digital image. The horizontal axis of the graph indicates the brightness range from black (0), on the left, to white (255), on the right. The vertical axis indicates the number of pixels for each brightness level. This makes the histogram a reliable indicator

White on white and black on black present similar photographic problems as white on black and vice versa. Often multiple exposures are required to capture detail at both ends of the recordable tonal spectrum. In both these examples the available light did not offer appropriate modeling for the black curtains and the white chair coverings and table clothes so some supplementary photographic lighting was added.

of what tones will or will not end up in any given digital capture. All tones falling outside the upper and/or lower limits of the histogram are simply not recorded by the sensor, so adjustments to shutter speed, aperture, or lighting will have to be made to place the image luminance range inside the 0–255 scale. When this condition is achieved, the digital photographer can shoot with absolute confidence that maximum image integrity will be preserved.

Not all digital cameras are capable of generating a histogram, but because it is such a powerful tool, I strongly recommend against using any camera that does not offer a histogram.

BRACKETING

It is essential to capture as much image information as possible with the camera. This is easy to do using a simple technique called exposure bracketing, which involves making a series of exposures above and below the exposure suggested by the lightmeter or the histogram. In practical terms, the camera is set at a certain ISO. The meter or histogram will suggest an exposure, for example F11 at 1/125 sec. Bracketing exposures of one full stop on either side of the measured exposure would yield F8 and F16 at 1/125 sec or alternately 1/60 and 1/250 sec at F11, since F-stop and shutter speed are reciprocally related. (Since image size varies slightly as the aperture is changed, for our purposes it is best to bracket by changing shutter speed.) After the shoot, the photographer can evaluate the bracketed exposures and select the best one for use (see images on page 24). If there is no best exposure, two or more brackets can be combined digitally for optimum effect (see pages 56–59).

DEPTH OF FIELD

Depth of field is directly related to the aperture size and refers to the range of acceptable image sharpness around the point of perfect focus. For example, a lens set at a moderately wide aperture and focused on an object ten feet away, might render two other objects positioned nine and twelve feet away as acceptably clear; in this case, the depth of field would be three feet. If, however, the aperture is much smaller, objects located at seven feet and at

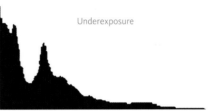

Normal Exposure

PIXELS

0 ——————— TONAL RANGE ——————— 255

Underexposure

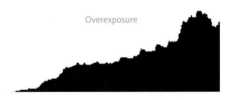

Overexposure

The histogram of a well-exposed image indicates that all tonal information is contained within the range the sensor can accommodate. Histograms of overexposed or underexposed images indicate that some tonal information falls outside the range that the sensor can record.

fourteen feet might be in focus, as well. The depth of field would now be seven feet.

Architectural subjects often require wide depth of field. Reducing aperture size of course also reduces the amount of light reaching the image plane and thus a longer exposure is needed. Therefore architectural photography often requires the use of a tripod. A longer exposure also means that movement will be depicted as blur, an effect that can add visual interest to a photograph.

2–2 LENSES FOR DIGITAL CAMERAS

The selection and use of various focal-length lenses in photography is influenced by our conditioned physiological and psychological seeing. Some optics, like perspective-control lenses, are used to put the world right according to our innate expectations. Other lenses, such as the extreme wide-angle "fish-eye," are used to shock and surprise; they can do this because the images they produce are so different from what our brains keep trying to see. For a given image size, lenses of different focal lengths have different fields of view, or angles of acceptance. The shorter the focal length, the wider the view. Since the opposite is also true, it stands to reason that in order to produce an identical-sized image of a particular object, a camera equipped with a relatively long focal-length lens must be farther away from the object than the same camera equipped with a shorter focal-length lens.

The choice of focal length also affects visual texture: at great distances the contours or surface variations of an object such as a building are relatively unimportant, while close-up topography becomes significant. By selecting lenses of different focal lengths the apparent depth of a complex subject may be altered as well, as the relative sizes of features in the foreground and the background are optically manipulated. It is easy to think of a wide-angle lens as a device to fit more content into the frame without having to move back, or a telephoto lens as a device for getting close to the subject without moving forward. But various focal lengths offer more than just a different angle of view. In fact, they each offer a different point of view, mechanically and aesthetically.

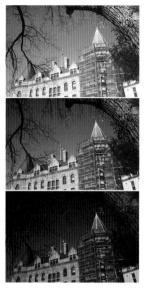

Bracketed exposures: The top image is overexposed; it has great detail in the shadows but burned-out highlights. The bottom exposure is underexposed; it exhibits lots of highlight detail, but the shadows are a featureless black. The middle image captures both highlight and shadow detail.

These objects were photographed close up at high magnification with a moderate telephoto lens set to its widest aperture: the depth of field here is just fractions of an inch. The exotic color heightens the effectiveness of the shots, which were used in a commercial advertising piece.

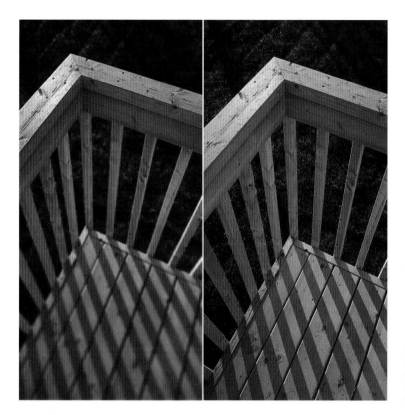

On the left, a large aperture, yielding shallow depth of field, was used to emphasize the railing detail. On the right, a small aperture rendered the entire scene in sharp focus.

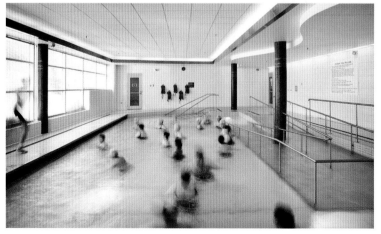

Still photographs record motion as blur. The degree of blur is determined by shutter speed in relation to the amount of camera or subject movement. I was asked to photograph this pool in use, but the brief required that participants in the exercise program remain anonymous. A slow shutter speed, about 1/4 sec, did the trick.

NORMAL LENSES (45–58 mm)

The focal length of a normal lens is determined by the length of the diagonal drawn from corner to corner across the format being considered. For the full-frame 35-mm SLR rectangle, the standard focal length is 43.266 mm, but most manufacturers use 50 mm or 55 mm. The perspective presented by a normal lens approximates what the eye/brain sees as normal.

WIDE-ANGLE LENSES (8–40 mm)

Wide-angle lenses cover a larger area than normal lenses. This capability can be very useful for architectural photography, which is often carried out in confined spaces. But wide-angle lenses can produce unnatural-looking images. So-called perspective distortion is both the curse and the blessing of wide-angle work.

The term perspective distortion only makes sense when the brain's response to the optical phenomena of nature is taken into account. The eye sees nearby small objects as large and far-away large objects as small, just as the camera does. And it sees parallel vertical lines of a building converging just as the camera does. Yet, unlike the camera, which simply records what the lens presents, our brains interpret and reconstruct the images streaming in from outside. The brain wants to see verticals that do not converge. In real-life situations the brain tries to correct apparent visual anomalies and up to a point, succeeds. But when we photograph a three-dimensional object and present it out of context on a two-dimensional surface such as a print, we bypass our image-processing capabilities. A photograph, being a fixed representation of a three-dimensional object, can only look how it looks. The power of lenses, and consequently the power of photography is derived from this ability to tease our optical pre-conditioning. The perspective offered by very wide to ultra-wide lenses (8–24-mm for SLR-format cameras) can push visual tension to the limits of tolerance.

Because of this dilemma architectural photographers have a love-hate relationship with short focal-length lenses. Often, we resort to wide-angle lenses because there is no other

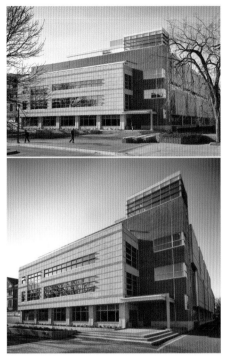

These photographs were taken from the same angle but with different lenses: a normal lens (top) and a wide-angle lens (bottom). The striking difference between the two images is the result of the closer camera-to-subject distance permitted by the wider lens.

option and not because we want to create a specific effect. In such situations the way in which the sizes of foreground and background objects are rendered in two dimensions is an unavoidable anomaly to be dealt with as discretely as possible. It can be a real eye-stopper when the ashtray on the coffee table looks as big as the fireplace.

To further complicate matters, there is another type of distortion that is unavoidably associated with wide-angle photography. Consider what happens when the image of a sphere is projected by a lens onto a flat piece of film or an electronic sensor: When located at the center of the frame, the sphere appears perfectly round, but as the spherical object is shifted away from the axis of the lens, its image becomes more and more elliptical. The effect is exaggerated as focal lengths get shorter.

Normal vision does not allow for entire rooms or large structures to be "swallowed" in one glance. In fact, our visual impression of a space is composed of a series of visual surveys that our minds integrate into a geometrically balanced whole: the shapes and relative proportions of individual objects and architectural embellishments are mentally preserved in a comfortable, natural way. This process of visual integration breaks down when we record the same scene in two dimensions from a single vantage point: this is exactly what happens when we use wide-angle lenses indoors.

The only solution to these aberrations is very careful placement of the camera and very careful rearrangement of the movable objects in the room—often just inches at a time. You will learn with experience which alterations in perspective and proportion are photographically acceptable and which will be perceived as outlandish.

MEDIUM TELEPHOTO LENSES (85–200 mm)

There are many circumstances when image magnification alone is the basis for choosing a long lens. If mechanical or geographical barriers separate photographer and subject, the right telephoto lens will pull in a decent image size. The degree of magnification

This detail shot from the Business Lounge at the Winnipeg Airport clearly illustrates the foreground/background size reversal that extreme wide-angle lenses can provide. We know, for example, that a chair is much larger than a push-plate on a door, but for this image the opposite is true. To further enhance the effect, the door-push is rendered in sharp focus, while the office furnishings behind the door are pleasantly blurred.

This graphic illustrates what happens when an image of a sphere is projected by a lens onto a two-dimensional surface. If the sphere is positioned along the optical axis, its projection is a circle. If the sphere is located away from the optical axis, the projected image is elliptical in shape. The stretching of the ellipse is exaggerated as the sphere is moved farther and farther away from the center of the frame.

is directly proportional to the increase in focal length. Thus, at the same camera-to-subject distance, a 200-mm lens yields an image that is four times the size of a 50-mm lens.

The significance of focusing error and camera movement increases with magnification. As focal lengths stretch it becomes more difficult to hand-hold telephoto lenses without a loss of sharpness due to camera motion. A rule of thumb is to never use a shutter speed slower than the reciprocal of the focal length of the taking lens, for example, for a 135-mm lens use a shutter speed of 1/125 sec, for a 500-mm use 1/500 sec.

Another reason to use telephoto lenses has to do with perspective distortion. Without perspective control, parallel lines appear correctly rectilinear only when photographed dead-on: objects photographed from below look to be tilted away from the camera, while objects photographed from above look to be tilted toward the camera. When the camera is positioned below the geometric middle of an object, the bottom of the object is closer to the lens than the top. The bottom is therefore rendered larger and the image looks bottom-heavy. A long lens puts the camera far enough away to make the relative difference in size between the top and the bottom of the subject insignificant. This balances the perspective and makes the picture feel right.

LONG TELEPHOTO LENSES (250–1000 mm)

Short focal lengths emphasize details closest to the camera and give them an appearance of exaggerated size compared to similar objects farther away from the camera. The greater shooting distance required to picture the same objects with long lenses tends to flatten perspective and yields images with a less noticeable sense of depth: the longer the focal length, the greater is the optical compression of natural perspective. When photographed with a long telephoto lens, the fields, foothills, and mountains of a landscape seem to merge together in the image. Similarly, blocks of city skyscrapers begin to look like pancake-thin copies of themselves pasted onto poster-board. Creative photographers take advantage of this phenomenon by watching for striking juxtapositions of objects normally seen as greatly separated.

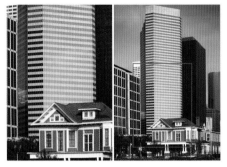

This pair of photographs was taken from an identical camera position. The image on the right was made with a moderate wide-angle lens and consequently includes a substantial swath of image information in both fore- and background. The image on the left was made with a telephoto lens that fills the frame with just a small portion of the image captured by the wider lens. In the telephoto view the various planes of the subject appear to be compressed together.

The fish-eye lens functions at the very edge of the extreme wide-angle category. Here a 15-mm rectilinear fish-eye (so named because the image is confined to a rectangular frame rather than a circle within the frame) was used to capture a unique interior view from a giant chain-hoist suspended from the roof of a metal fabrication plant. The bottom image was made from the same vantage point, but with a conventional 17-mm wide-angle lens. The fish-eye view is interesting, but useful only very occasionally.

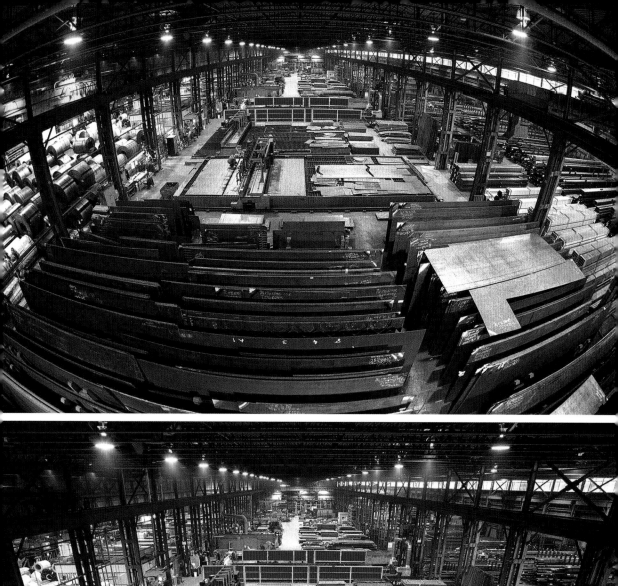
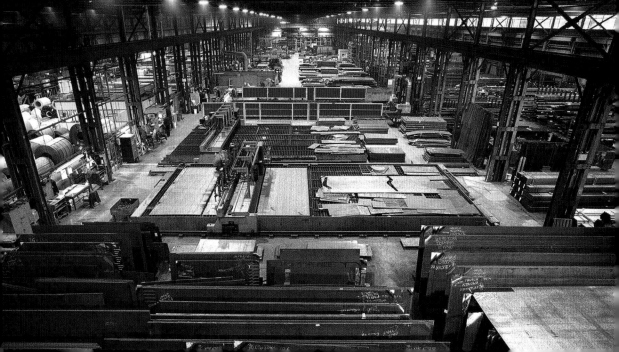

This urban scene was shot with an extreme telephoto lens (left). Note how atmospheric pollution such as dust and smog has rendered the sky gray and obscured the buildings in the far distance. A combination of polarizer and uv filtration plus some Photoshop enhancements brought back the true color of the sky along with definition in the background objects (right).

Long telephoto lenses can also be useful to shoot details of buildings that would otherwise be difficult to capture. Sometimes the combination of extremely long lenses and air pollution or thermally induced turbulence will introduce odd distortions or color shifts. Like the compression effect, such optical mutations can be photographically interesting; if not, they can be attenuated by polarizing, ultra-violet, or color-correction filters, supplemented by Photoshop corrections.

As we have learned, depth of field is a function of aperture size, which in turn is a function of focal length; the longer the focal length, the shallower is the depth of field at a given F-stop, everything else being equal. At wide apertures the depth of field may be a matter of inches or even fractions of inches. Sometimes this narrow depth of field can be very effectively used to isolate or highlight certain objects or areas within the frame.

PERSPECTIVE-CONTROL LENSES

Perspective-control lenses are in a class of their own; they are available in a limited range of focal lengths, but they are so useful for architectural photography that they warrant detailed study. Basically, they are specialized wide-angle lenses with exceptionally broad coverage. PC lenses are mounted in a mechanism that allows the optical axis to be shifted both horizontally and vertically. This "shiftability" mimics the view camera, which also requires an image circle wide enough to prevent cut-off on extreme movements.

Nikon and Canon are the leaders in DSLR PC lenses. The Nikon design uses a sliding/rotating collar that provides adjustability but precludes an automatic diaphragm or auto-focus, so Nikon PC lenses must be manually opened to maximum aperture for focusing and then closed down for shooting. This operation is made easier by dual diaphragm adjusting rings—one ring is positioned

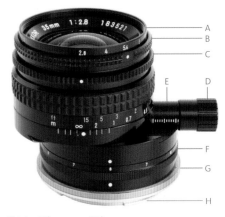

This is a Nikon 35-mm PC lens.

A Aperture scale
B Pre-set aperture ring with click-stops
C Sliding aperture ring that permits quick opening and closing for focusing
D Knob that controls the degree of lens shift for perspective control
E Scale indicating the degree of shift
F Numbers related to the rotation of the lens indicating how the axis of the shift is oriented
G Brass adapter that permits the Nikon lens to be fitted to a Canon lens mount (H)

The converging lines on this image give it a playful quality that is appropriate to the subject matter. The alterations in perspective and proportion are acceptable in this context.

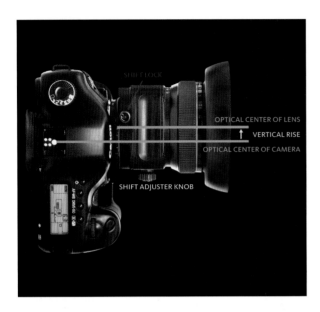

SHIFT LOCK

OPTICAL CENTER OF LENS

↑ VERTICAL RISE

OPTICAL CENTER OF CAMERA

SHIFT ADJUSTER KNOB

This is a Canon 5D full-frame DSLR camera fitted with a Canon 24-mm tilt/shift PC lens that permits optical perspective control in the camera. Note the vertical displacement of the lens in this illustration.

by locking click-stops to the required F-stop, while the second operates freely between maximum opening and the pre-set minimum. This arrangement makes exact F-stop bracketing a little awkward when the camera is not mounted on a tripod, but for most purposes the arrangement works well. A used 35-mm PC lens costs approximately $500, while the 28-mm PC ranges from $800 to $900. Both Nikon PC lenses can be made to fit Canon camera bodies with an adapter.

Canon offers a range of PC lenses: a 24-mm F3.5, a 45-mm F2.8, and a 90-mm F2.8. All these lenses combine PC movements with adjustable tilt for focus control. (Focus control can be used to reduce depth of field for exaggerated narrow-focus effects, or for enhancing depth of field to allow the use of larger apertures and faster shutter speeds, just like a view camera.) The Canon lenses must be focused manually but all have auto-diaphragms. They are priced new at approximately $1,250 each, but since they were introduced only a few years ago, they are hard to find on the used market. The 45-mm and 90-mm versions are very useful for shooting details and for overall views at a distance. When used with a full-frame DSLR the 24-mm version is wonderfully suited for

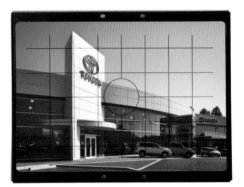

Some prosumer and many professional DSLR cameras feature interchangeable focusing screens. A screen with a grid pattern etched into the surface makes alignment of vertical and horizontal lines much easier.

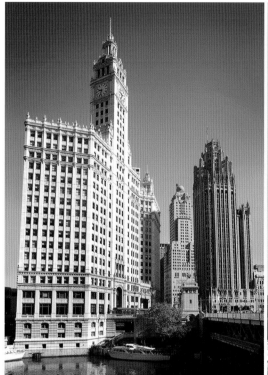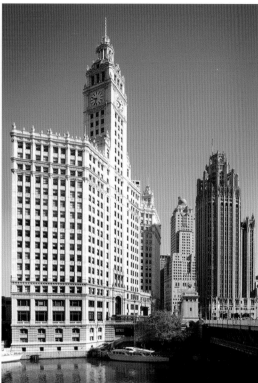

interiors and for tight situations outdoors. I use this lens for about 75 percent of my architectural work.

 One warning applies to the use of all PC lenses with SLR and DSLR cameras using BTL lightmeters: it is necessary to meter before shifting the lens. When PC lenses are shifted for perspective adjustment, the altered optical alignment causes the viewfinder to darken, so BTL lightmeter readings become inaccurate. To achieve precise perspective control the camera must be mounted on a tripod and carefully leveled. Some tripod heads have a bubble level built in, but no SLR cameras do—the solution is an accessory level that slips into the camera's accessory shoe. High-end Canon and Nikon cameras accept interchangeable focusing screens, and these manufacturers offer screens with etched grids that greatly facilitate lining up rectilinear architectural shots.

These photos of the Wrigley Building in Chicago demonstrate that we have a natural inclination toward rectilinearity, particularly in complex architectural subjects. The view with the converging verticals (left) is simply not as appealing as the image that is in perfect vertical alignment (right).

2–3 WHAT IS A DIGITAL IMAGE?

The visual world is composed of dots. Photographic film records reality with tiny crystals of silver bromide salts; digital cameras record the signals produced by miniature sensor elements; and the human eye registers light by way of an array of specialized cells on the retina. The brain, seeking as it does to harmonize the elements of perception, automatically renders our microscopically fragmented vision into a smooth, continuous image. Our perception of reality as a highly detailed visual field is an illusion.

A conventional black-and-white photographic image is composed of particles of metallic silver suspended in a gelatin emulsion spread on a paper or plastic base. A conventional color photographic image is composed of particles of organic dye suspended in several emulsion layers superimposed on a paper or plastic base. In both cases, the image-forming components are so small as to be nearly invisible to the naked eye, yet together they permit the image to exist as a physical object, a collectivity of real particles that can be seen and touched.

A digital image does not exist in the same way as a conventional image in that it cannot be seen or touched without some sort of physical interface. We can see and touch an inkjet print or an LCD screen, but we cannot see or touch the digital image that it represents. A digital image exists only as a mathematically coded series of electrical or magnetic potentials inside an electronic device.

A computer manipulates digital images in the same way that the brain manipulates thoughts. Consciousness is supported by a massively interconnected network of neurons: no brain, no thoughts. Inside a computer, digital images are supported by a somewhat less sophisticated network of electronic switches and magnetic or optical storage devices: no hardware, no image.

2–4 HOW AN IMAGE IS DIGITIZED

A digital image comes into being through a system of electronic recording known as "digital capture." Fundamental to this endeavor is some form of a solid-state optical transducer that converts light into electrical energy. Millions of such transducers—or

pixels, short for picture elements—form the heart of all electronic imaging hardware. An electronic camera uses many sensing elements that are grouped together into a grid of pixels. Each pixel is assigned a value that corresponds to the brightness of the light that strikes it. This value is encoded as a sequence of zeros and ones. In computer terminology, each zero and each one is a bit and eight bits form one byte. The black-and-white data for one pixel occupies one byte of memory. For a color image, one byte per primary color component is required for each color pixel, hence the term 24-bit color. All the bytes from all the pixels are stored as a data block, or file. The file size for color image storage is necessarily three times that of a comparable black-and-white image.

This diagram shows how a bi-tonal image (only black and white tones) is described by a series of ones and zeros in the binary system. More complicated images with a wide range of tones and colors are described by much longer strings of zeros and ones.

2-5 SENSOR TYPES

There are two significant sensor configurations. Scanning backs, which can be attached to large- or medium-format cameras, use a precision worm-drive arrangement to move a thin linear array of tiny red, green, and blue sensing elements across the image area at the plane of focus; a similar set-up is used in flatbed scanners that digitize existing photographs and transparencies. A modern scanning back builds an image file by adding together up to 65,000 consecutive stripes of data created incrementally as a linear sensor array travels slowly across the plane of focus. A typical scanning back covers a large image area (72 by 96 mm) so it can be used on 4x5 view cameras with a full range of movements and regular large-format wide-angle lenses. Scanning backs record high-resolution full-color images in one pass, but they operate so slowly that moving objects cannot be accurately rendered. Exposures are typically a few seconds in bright daylight up to several minutes in dim interiors.

More common is a square or rectangular sensor consisting of a large number of sensing elements tightly packed together into a two-dimensional array that can capture an entire image in one exposure, just like film. There are two main types of sensors: CCDs (Charge-Coupled Device) or CMOSS (Complementary Metal-Oxide Semiconductor), and they come in various sizes. Only a handful of high-end DSLR cameras feature full-frame sensors—

Digital backs for medium- and large-format cameras: A digital back that mounts onto modular medium-format cameras just like a film back (left), the BetterLight Scan Back fitted to a 4x5 view camera (center), and the BetterLight Scan Back interior (right). The red outline indicates the precision linear sensor array. (There are no full-frame medium-format backs as yet, so extreme wide-angle work is restricted to stitching two or more images together.)

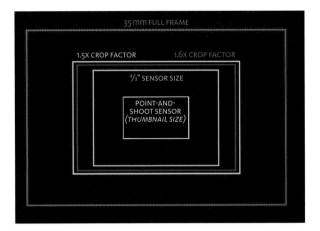

This diagram shows the relative sizes of typical digital sensors. The outer rectangle (magenta) is the traditional 24x36-mm frame size of the 35-mm format. Full-frame sensors of this size cost about six times more to manufacture than the smaller 1.5–1.6 focal factor sensors typical of more common DSLRs.

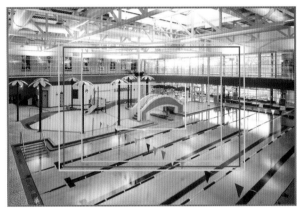

This image shows what happens when a complex interior view is captured with different size sensors, using the same lens and the same camera position.

This shot of the sun rising over the Ganges River near Varanasi, India, is relatively uncomplicated, and some of the tighter cropping associated with small sensors works pretty well.

sensors that are identical in size to the traditional 35-mm film format. Most DSLRs use sensors that are about one third smaller, so the effective focal length of the taking lens must be increased by an appropriate focal factor. Focal factors range from about 1.3 to 2. For example, a sensor with a focal factor of 1.5 would make a 20-mm lens behave like a 35-mm lens (20 mm x 1.5 = 35 mm), resulting in a proportional reduction in angle of view. Typical point-and-shoot cameras feature 5–6-megapixel (MP) sensor arrays approximately 15 by 22 mm in size. Most prosumer DSLRs use 19 by 29 mm, 6–10-MP arrays. As this is being written, only the high-end 16.7-MP Canon 1Ds MKII and its prosumer cousin, the 12.6-MP Canon 5MD are available with full-frame sensors. Full-frame sensors have a focal factor of 1, so there is no loss of angle of view.

Most architectural photography requires wide-angle lenses and perspective control, so sensor size is of critical importance. Since PC lenses were originally designed to work with full-frame 35-mm film cameras, they work well on full-frame DSLRs, but they are not so useful on DSLRs with smaller sensors.

3 THE DIGITAL WORKFLOW

Not so long ago a photo project would conclude with editing contact sheets provided by a lab and overseeing the printing of a few photographic enlargements. Today photographers are responsible for images from creation through digital "development" and electronic distribution. Digital workflow is the term used to describe the processes of digital image capture, electronic image processing, and the output and delivery of finished high-resolution image files.

Without a reliable and efficient digital workflow, the digital photographer will be quickly buried under terabytes of unmanageable data.

3–1 MEMORY CARDS

Digital photography depends on electronic devices for the storage of image information. There are two main options: memory cards or miniaturized hard disks called "microdrives." Microdrives are cheaper—dollar per megabyte—than memory cards, but not as reliable. CF (Compact Flash) cards—as opposed to the smaller SD (Secure Digital) memory cards—are very robust; I've dropped some of my cards several times, inadvertently sat on them, even stepped on them accidentally, all without trouble. Microdrives, being mechanical devices, are inevitably more fragile. A few precautions in relation to card selection and use will make your image storage experience more enjoyable, regardless of which type of card you use.

First, buy the highest-quality, fastest-speed cards you can afford. "Pro"-type cards are designed to work under a wider range of temperature and mechanical stress. They also read and write data faster, which becomes a major concern as image files increase in size. Second, don't use cards that are so big that an entire shoot will be recorded on one device. An 8-gigabyte (GB) card may seem attractive, but it is better to spread a day's work across four or five 2-GB cards. Thus, if a malfunction occurs, all your efforts will not evaporate into cyberspace in one stroke.

Third, remember that all storage cards must be electronically configured to accept data through a process called formatting. Once removed from the camera, the card can be read by a computer using a card reader. It might seem easier to use the computer to delete files from a card after all required image data has been downloaded, but erasing or even simply reading a card with a computer may subtly or dramatically alter the card's internal file structure, possibly making it unusable once it is back inside the camera. You should therefore always reformat the card in your digital camera before use.

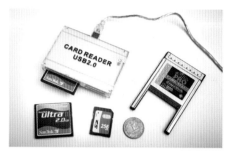

Memory cards and card readers: A multi-format flash memory card reader with a CF card inserted into one of its slots (top left), a high-speed CF card reader that fits into the PCMCIA (Personal Computer Memory Card International Association) expansion slot found on many laptop computers (right), and a CF memory card and a SD memory card (foreground).

Finally, use the fastest card reader you can find. Most card readers are 16-bit devices, transfering data 16 bits at a time, but there are a handful of 32-bit card readers; when used with a compatible computer, these units cut transfer times approximately in half.

3–2 RAW FILES

All high-end digital cameras provide the opportunity to work with raw files, which are a complete record of all the unprocessed data generated by the camera sensor. Since human beings are conditioned to expect reality to appear in a certain way—not too bright, not too dark, not too flat, and without outrageous color or density anomalies—the information that a raw file carries has to be processed. The common file formats such as JPEG, TIFF, GIF, and others, are all optimized for comfortable image viewing on a monitor screen or for printing on paper. Most consumer digital cameras use only the JPEG (Joint Photographic Expert Group) file format, at the expense of discarding some of the image data that is recorded. The proficient digital imager, however, wants and needs direct access to every available morsel of information in any given digital image. I therefore recommend the raw file format as your standard selection if it is available on your camera. There are several proprietary raw file formats, such as Canon's .CRW and .CR2, Minolta's .MRW, Olympus's .ORF, and Nikon's .NEF, which can be converted

The image on the left is the raw, unprocessed file just as it came off the sensor. It was converted into a JPEG file by the camera's built-in raw-file converter (center) and enhanced with color, tonal-range, and perspective correction in Photoshop (right).

to the common file formats required for viewing and printing with the help of a raw file converter.

The creation of a raw file is a complex process: Photo-sensitive detectors collect incoming photons and create an electrical charge that is directly proportional to the amount of light they each receive. To make a color image, each photo-sensor is filtered so that it reads either red, green, or blue light. Twice as many green filters are used as red or blue because our eyes are most sensitive to green light. The red-filtered sensing elements produce a gray-scale value proportional to the amount of red light reaching the sensor, the green-filtered elements produce a gray-scale value proportional to the amount of green light reaching the sensor, and the blue-filtered elements produce a gray-scale value proportional to the amount of blue light reaching the sensor. Raw files contain the data of the gray-scale values for each pixel site, together with a map of the actual physical arrangement of the color filters on the sensor matrix. RAW converter software uses all this data to render the gray-scale capture into a color image by interpolating color information from the relative luminance levels between adjacent pixels. The RAW converter has a number of other very important jobs: it applies an overall white balance (i.e. it adjusts the relative brightness of the red, green, and blue components so that the brightest object in an image appears as white or neutral in color); it redistributes the tonal information to correspond more closely to the way our eyes see light and shade; it performs a combination of edge-detection and anti-aliasing to avoid color artifacts, for noise reduction, and for image sharpening; and it translates the image data, captured by most sensors at a 12-bit depth—or 4,096 levels of tonal information per pixel—into the 16-bit or 8-bit formats used for reproduction.

All of the above is rendered automatically by pre-determined algorithms—with attendant permanent data loss—when one trusts the camera to output JPEG files only. Because of the complex processes involved, raw file conversion should be done mindfully, however, so that all the critical steps are performed in a way that maximizes the potential of each image. Camera manufacturers offer a variety of conversion programs, such

A Bayer filter grid is applied to all digital sensor arrays in order to capture color information from the black-and-white sensing elements. Because human vision is more sensitive to green, twice as many green filters are deployed in the Bayer configuration than red or blue sensors.

as Capture One (sold by Phase One), Canon's Digital Photo Pro-
fessional, and Nikon's Capture NX. Adobe Photoshop has its own
powerful solution, called Camera RAW. My favorite file converter
is DxO's Optic Pro, which is capable of making remedial adjust-
ments to image errors such as edge sharpness, edge fall-off, chro-
matic aberration, and others, that are specific to particular lens/
camera combinations.

3–3 FILE FORMATS AND COMPRESSION TECHNIQUES

High-resolution image files necessarily incorporate a great deal
of information and can become quite large. There are a number
of ways to reduce (or compress) file size, each of which describes
image detail and color content in a different way.

LOSSY VS. LOSSLESS COMPRESSION

A compression algorithm shrinks image information into a com-
pact code. A lossless algorithm makes a digital image smaller
without discarding information. It looks for more efficient ways
to represent an image, while making no compromises in accuracy.
In contrast, lossy algorithms permit some degradation of image
information in order to achieve the smallest possible file size.

A lossless algorithm will look for recurring patterns in
the image and replace each occurrence with an encoded abbre-
viation, thereby shrinking file size while retaining image integ-
rity. Lossy compression cuts file size by editing image data in a
way that is similar to summarizing a document. The content of
a multi-page document can be condensed down to a one-page
précis, but an exact duplicate of the original document cannot be
reconstructed from a short summary. An image recreated from
a compressed file will always be only an approximate replica of
the original uncompressed file. The discrepancy between the two
is determined by the degree of compression and by the nature
of the compression scheme. Simply opening and closing a com-
pressed file will not degrade it at all, but each time a compressed
file is opened, edited, saved, and then recompressed, some data
is irretrievably lost.

JPEG (.JPG)

JPEG (Joint Photographic Experts Group) is the most commonly used digital image format. It is a lossy compression scheme that provides a user-selectable degree of compression. Universally compatible with web browsers and image editing software, it can compress file size by up to twenty times. The JPEG system divides an image into eight-pixel squares that are compressed independently. These squares are virtually invisible when very little compression is applied, but as compression is increased, they become more visible.

The process of choosing exactly how much compression to apply involves a trade-off between file size and image quality. The JPEG protocol offers a dozen different options. Level 12 yields the maximum quality image after decompression. Such an image is difficult to distinguish from the uncompressed original, despite being about 1/5 its size. The eight-pixel squares are much more noticeable in a Level 6 medium-quality JPEG, but the quality is usually fine for web use. A low-quality Level 1 JPEG shows serious image degradation, with obvious artifacts around edges.

As the pixel pattern becomes visible, stair-like lines ("jaggies") appear where there should be only straight lines or uninterrupted curves. This effect can be reduced somewhat by antialiasing or smoothing. Antialiasing works by filling in the "steps" with manufactured pixels. Some amount of jaggies are always present in a JPEG file, but they are less obvious at low and moderate compression levels. Sharpening increases edge-contrast and thus makes jaggies more noticeable.

Consumer digital cameras save to JPEG format by default, and JPEG is the format of choice for nearly all photographs on the web. When the degree of compression is set to properly match the final output requirements, JPEG does a very good job with continuous-tone images.

TIFF (.TIFF)

TIFF (Tagged Image File Format) is a popular format supported by the majority of image-editing programs and all computer platforms. It can be moderately compressed in a lossless way with

These two small areas (green and yellow squares) enlarged from a high-resolution TIFF file (left) show terrific image sharpness and smoothness. On the right, the same image file has been reduced in size by a factor of 20 using extreme JPEG compression. At modest magnification, it is difficult to tell lithographic reproductions of the TIFF and the JPEG apart. At higher magnification, the difference is very obvious. Note the eight-pixel blocks and the jagged lines evident in the magnified insets from the JPEG file.

LZW (Lempel-Ziv-Welch) or Zip compression. TIFF is favored for images destined for lithographic printing because of its flexibility and strong color support: while JPEG supports only 8-bit/channel single-layer RGB images, TIFF supports up to 32-bit/channel multi-layer images. Some digital cameras offer TIFF output as an uncompressed alternative to JPEG. Due to space and processing constraints 8-bit/channel is typical, although high-end cameras and scanners offer 14–24-bits/channel.

PSD (.PSD)

As digital imaging becomes more pervasive and more sophisticated, the ability to edit an image becomes more important as well. An application-specific format often offers the maximum editing possibilities. Photoshop is the industry standard, and PSD (Photoshop Data file) is Photoshop's native file format. Since PSD supports some Photoshop features that nonproprietary formats such as TIFF and JPEG do not, a majority of imaging professionals work on their files in PSD and then export them as TIFFs for distribution.

PDF (.PDF)

Adobe's PDF (Portable Document Format) preserves all the elements of a printed document as an electronic image that can be viewed, printed, copied onto disk, or forwarded over the Internet. PDF files can be created and modified in Adobe Acrobat, Acrobat Capture, or in Photoshop itself, and viewed with Acrobat Reader. PDF files are especially useful for documents such as magazine articles, product brochures, technical manuals, and flyers, in short, any print application where it is important to preserve the original graphic appearance. PDF offers a choice of image compression schemes (lossy JPEG or lossless LZW) for quick uploads and downloads online.

RAW [.RAW / .NEF (NIKON) /.DCR (KODAK) / .CR2 (CANON) / .MRW (MINOLTA), ETC.]

RAW is not an abbreviation or acronym: it means "raw," as in uncooked or unprocessed. As we have learned, any RAW file contains the original image information (along with metadata—

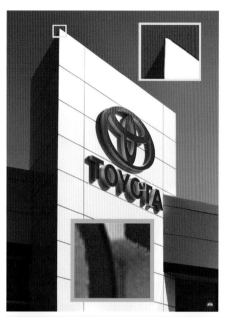

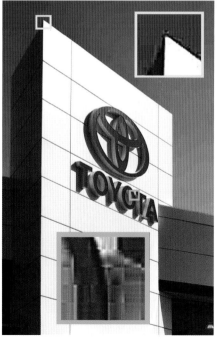

information about how and when the image was made) as it comes off the sensor before in-camera processing. There is as yet no universal RAW format: each file type is unique to each manufacturer and sometimes even unique to specific camera models. RAW files are three or four times smaller than TIFF files for the same image. The RAW format is attractive because all possible image data is retained, but the plethora of proprietary versions make archival storage a worry as older iterations slide into disuse. (Canon has already dropped support for their .SDK format, which was only introduced in 2001. Minolta has left the camera business entirely.)

DNG (.DNG)

As a response to the RAW Tower of Babel situation, Adobe has developed the DNG (Digital Negative) format. DNG separates metadata into two types: common and proprietary. Software that supports DNG will be able to open and render any manufacturer's raw file, but the manufacturer can still incorporate custom information for use by its own RAW-processing utility. DNG is an extension of the latest version of the TIFF format so it supports color depth beyond 24-bit, which is essential for high dynamic range imaging (see page 56–59). In an effort to float DNG as a truly universal solution, Adobe has officially guaranteed support for the specification in perpetuity. As this is being written, DNG is gaining acceptance as a viable standard slowly but steadily.

3–4 COLOR MANAGEMENT

Keeping the color of a photograph the way it should be is one of the most difficult issues in digital photography. Every camera, computer, monitor, scanner, and printer has a unique visual signature. The process of preserving color fidelity across an ocean of hardware is called color management. To understand the importance of color management, it helps to be familiar with a few essential terms.

COLOR MODEL AND COLOR SPACE

A color model is a mathematical method of describing color by numbers. Cameras use the RGB color model, an additive system

THE DIGITAL WORKFLOW

3–3 FILE FORMATS AND COMPRESSION TECHNIQUES
 DNG
3–4 COLOR MANAGEMENT
 COLOR MODEL AND COLOR SPACE
 ICC PROFILES

in which all colors are derived from combinations of the primary colors, red, green, and blue. Printers use the CMYK model, in which all colors are derived from combinations of the complementary primaries, cyan, magenta, and yellow. (In the CMYK process black—the K in CMYK—is added to increase overall density.) A color space is a link between the abstract mathematical color model and the real world; it is a mapping function that connects a color model with a particular set of reference colors. This reference set—when integrated into a real-world color-handling device such as a camera, printer, or monitor—is known as a gamut. The gamut is, in effect, the range of real colors that a particular device is capable of generating, recording, or reproducing.

The venerable SRGB color space is relatively small: it has only 256 colors, just enough to work well on a CRT monitor. Adobe RGB (1998) has a greater range of colors, some of which are various shades of the same color. This makes it better suited for subtle rendering of color on a computer screen or for printed reproductions on paper. Recently, Adobe introduced ProPhoto RGB for use with their raw converter, which is the only color space today capable of encompassing virtually all the color information encoded in the raw files generated by modern high-end digital cameras.

If possible, work in the largest color space available, in the camera, in the raw converter, and in Photoshop, so that the maximum amount of information about an image is retained throughout the entire workflow.

ICC PROFILES

Any attempt to describe a digital image to a digital device would be futile without a standardized communication protocol. An initiative of the International Color Consortium (http://www.color.org/), established in 1993 by Apple and several other imaging industry leaders in order to create an open, vendor-neutral, cross-platform color management system, has been widely adopted for this purpose. The ICC profile is a compact, portable method of encapsulating color characteristics electronically.

Participating hardware manufacturers provide ICC profiles for each of their products. These profiles are used to translate

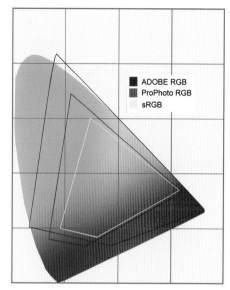

ADOBE RGB
ProPhoto RGB
sRGB

This graphic displays the relative sizes of the SRGB color space (yellow outline), the larger Adobe RGB color space, and the even larger ProPhoto RGB color space. SRGB approximates the color gamut of most computer displays. Adobe RGB 1998 encompasses most of the colors achievable on CMYK printers. The ProPhoto RGB color space includes all the colors that modern digital sensors can capture, many of which are invisible to the SRGB or Adobe RGB color spaces.

color data created on one device into another device's native color space. Participating software manufacturers incorporate ICC literacy into their digital workflows. Image files with embedded ICC profiles thus retain their color fidelity while interacting with ICC-compliant applications, operating systems, and hardware.

The process begins by selecting a wide-gamut working space in the camera. The working space digitally tags all image files with the specific ICC profile associated with that color space. This information is carried forward into the raw processor, and then into Photoshop. Once in Photoshop, a calibrated monitor and printer will help maintain the color integrity of the images as they are prepared for final digital output or printing.

Hardware color calibration is the definitive approach to reliable color management throughout the digital workflow. Monitor calibration is a critical aspect of this process. Here we see the Gretag monitor calibration device in use. The calibration device is suspended over the monitor in order to make direct measurements at the surface of the screen. The bottom of the device is visible in the inset. Note the array of sensor elements in the center, surrounded by a number of soft rubber suction cups that attach the device to the screen surface. A dialogue box from Gretag's calibration software is shown on the monitor.

CALIBRATION

Accurate color management requires an accurate ICC profile for every link in the hardware chain. In the best of all possible worlds, the ICC profiles provided by manufacturers would work perfectly for every device and every application. But unfortunately, there are numerous complications. Monitors age, print heads wear, and the many varieties of inks and papers all interact uniquely. In addition, the infinite possibilities provided by image-handling software easily transmute into a series of color management headaches.

The remedy is standardization through calibration. The simplest calibration method involves adjusting the color settings of the monitor to achieve a best-guess visual match with printer output by trial and error. A more sophisticated visual method uses software assistance to adjust the monitor; for the MAC select Displays : Calibrate from the Systems Preferences menu, for Windows open the Adobe Gamma utility and follow the prompts.

The best visual evaluation, even when supported by software, can only be a rough approximation of perfect color, though; hardware-based calibration is required for precise control. The hardware approach uses sensors and standardized test targets to measure the actual color generated or displayed by cameras, printers, and monitors; these measurements are analyzed with proprietary software and then custom ICC profiles are created for each device. Complete systems, such as Eye-One from

During the course of the calibration process the Gretag software generates dozens of patches of specific colors that are measured by a sensor positioned on the screen. The resulting data is used to create a perfect color profile of the monitor.

Gretag-Macbeth (http://usa.gretagmacbethstore.com), PrintFix from Colorvision (http://www.colorvision.com), and Monaco-Color from Xrite (http://www.xritephoto.com), are available in pack-aged kits for $300–$1500.

3–5 IMAGE EDITING

The work of digital photography is half shooting and half electronic image enhancement. Digital image manipulation techniques fall into two categories: remedial or creative. Making the former effective but invisible and the latter unique yet appealing requires both experience and a measure of good taste.

There are numerous image-editing softwares on the market, but Photoshop towers over the digital graphic arts landscape, and by extension, the world of digital architectural photography. The program provides scores of different ways to implement

Photoshop's opening screen: The horizontal toolbar at the top contains drop-down menus for file operations and program preferences while the vertical toolbar at the left lists specific software tools and options for performing a huge range of image adjustments and alterations. Some of the most important tools for our purposes are:

A Lasso Tool
B Magic Wand
C Crop Tool
D Clone Stamp Tool
E Eraser Tool

any imaginable graphic enhancement, modification, or correction. Where the fashion realm has wrinkles, pimples, and sagging appendages to deal with, we in the architectural realm have utility poles, oil stains, and uneven blinds. Where the advertising world has melting ice cream, flat beer, and gray meat, we have gray skies, recalcitrant delivery vehicles, and brown grass. There is no image defect or deficiency that cannot be remedied, or at least remediated, with Photoshop. But error correction is only one aspect of Photoshop's power. The program is also an interface that intelligently interconnects cameras, scanners, computers, printers, monitors, film, paper, and the Internet. Photoshop is a durable standard because of its enormous scope and flexibility; for professional-level work, the $700 investment is an expenditure that I strongly endorse.

There is no reason not to plunge right into Photoshop work. Manuals and DVD tutorials are available at any store, real or virtual, that sells technical books. Or simply hire a knowledgeable student willing to provide a couple of hours of instruction a week.

SPECIALTY SOFTWARE FOR
ARCHITECTURAL PHOTOGRAPHY

Photoshop is powerful but not all-powerful. Happily, the less robust aspects of Photoshop can be easily addressed with aftermarket software. These plug-in programs can be quite sophisticated in their own right and once installed can be accessed from within Photoshop through the regular menus. Helpful plug-ins for architectural photography include the following:

PHOTOKIT SHARPENER
HTTP://WWW.PIXELGENIUS.COM

There are several roughly interchangeable terms such as acutance, resolution, and sharpness that are used to describe the clarity of photographs. Sharpness is perhaps the most common. Any digital image is ultimately a mathematical construct. Photoshop provides a handful of options for electronically enhancing sharpness. Sharpen, Sharpen Edges, Unsharp Masking, and Smart Sharpen all

Two dialogue boxes from PhotoKit Sharpener, displaying one particular choice for output sharpening (top) and a particular choice for input sharpening (bottom).

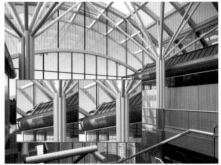

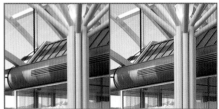

These composite images illustrate how Photokit Sharpener works to enhance apparent sharpness in a print. The detail on the left shows the condition before output sharpening. The detail on the right has been altered by Photokit Sharpener. The enhanced image looks worse on the screen, but better than the original version once printed.

operate by tweaking the tonal separation at and between adjoining image areas of different brightness and/or color. Of these options, Smart Sharpen is the most sophisticated, providing a number of controls over the style and intensity of modifications to these critical junctions. The PhotoKit Sharpener plug-in transcends the effectiveness of Photoshop's Smart Sharpen filter by abandoning the idea of a one-shot sharpening solution. Image-processing professionals have found that sharpening is best done in at least two steps—once during or just after the scanning or raw conversion stage, and once again after all Photoshop enhancements are complete. PhotoKit Sharpener goes further by providing three separate sharpening opportunities:

1. Capture Sharpening: this is applied during or immediately after scanning or raw conversion in order to restore detail lost during the image capture process.

2. Creative Sharpening: creative sharpening takes into account the local textural characteristics of the image.

3. Output Sharpening: this is applied to a final image just before printing. Settings are determined according to the size and type of output.

All PhotoKit Sharpening operations result in a dedicated sharpening layer so changes are non-destructive and can be modified or reversed easily.

NOISE NINJA
HTTP://WWW.PICTURECODE.COM

Noise is a fact of life in digital imaging just as film grain was a fact of life in silver-based imaging. A modern sensor operating at 50 or 100 ISO is virtually noise-free, but once sensitivity is boosted beyond 400 ISO, digital noise can become a problem. The noise reduction tools built into Photoshop, such as Despeckle, Reduce Noise, or Dust and Scratches selectively blur image details in order to attenuate small, low-level artifacts. Controls are provided to set a pixel-level threshold as well as the intensity of the blur. The net effect is to disguise noise at the cost of subtle image detail. The Noise Ninja plug-in instead uses complex mathematical

On this enlargement (top) from a 36-MB image made by a Canon 5D at ISO 1600, digital noise related to the high ISO is clearly evident. PictureCode's Noise Ninja software is used to fix the problem: The image on the left is a portion of the photo that is to be cleaned up. The image on the right shows the magnified view from the processed image.

algorithms to identify and suppress noise of specific frequencies, brightness, color, and pixel size. Despite its sophistication, Noise Ninja is easy to use.

ICORRECT EDIT LAB PRO
HTTP://WWW.PICTOCOLOR.COM

Natural, accurate color is essential for quality architectural photography. Pictocolor's iCorrect Edit Lab Pro plug-in makes the process of color correction relatively easy. The opening menu offers four tool sets identified by four distinct tool tabs. Under Tab 1 global color balance is achieved by simply clicking on any neutral (i.e. black, white, or gray) color in the preview window. Tab 2 offers automated black-point, white-point, and tonal range adjustments. Sliders found under Tab 3 permit adjustment of brightness, contrast, and color saturation, together with independent fine-tuning of highlight and shadow density. Tab 4 provides very precise control over the brightness and saturation of specific user-selectable hues. Those who find the range of adjustments overwhelming can choose the surprisingly useful SmartColor option for one-click automation of all iCorrect functions.

PHOTOFIXLENS
HTTP://WWW.HUMANSOFTWARE.COM

All wide-angle lenses suffer from some degree of barrel distortion that makes the vertical and horizontal lines in affected images appear to bend outward. Similarly, most telephoto lenses suffer from some degree of pincushion distortion that makes vertical and horizontal lines bow inward. The PhotoFixLens plug-in efficiently addresses these issues with an easy-to-understand interface featuring a set of straightforward slider controls supported by an active real-time preview.

NIK COLOR EFEX PRO
HTTP://WWW.NIKMULTIMEDIA.COM

Nik Color EFEX Pro offers seventy-five user-adjustable digital simulations that mimic the behavior of conventional photographic filters. Special effects such as infrared conversion, cross-processing,

iCorrect Edit Lab is a useful color correction plug-in. The top image illustrates how individual colors can be altered in hue and saturation. These controls are very precise; the preview window in this screen shows how the saturation of the red on the crane has been increased without affecting the rest of the picture. The dialogue box on the bottom shows individual non-destructive tonal controls for apparent brightness and contrast, as well as sliders for separately brightening or darkening highlights and shadows.

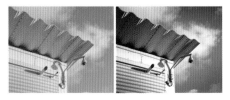

The power of iCorrect: The image on the left is only a few clicks away from becoming the image on the right. White balance and apparent brightness and contrast are easily enhanced without throwing away image information.

THE DIGITAL WORKFLOW

3–5 IMAGE EDITING
 ICORRECT EDIT LAB PRO
 PHOTOFIXLENS
 NIK COLOR EFEX PRO
 CONVERT TO B&W PRO

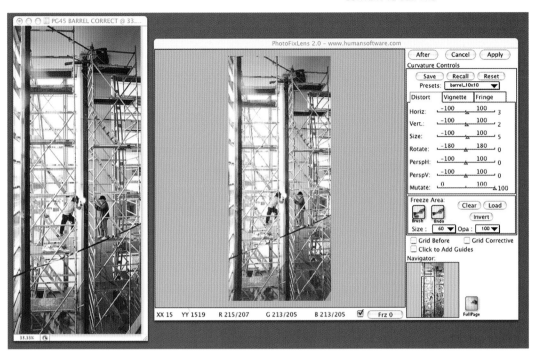

solarization, and soft focus are also included. All Color EFEX controls can be applied incrementally to part or all of an image.

CONVERT TO B&W PRO
HTTP://WWW.THEIMAGINGFACTORY.COM

Consumer magazines and professional journals print black-and-white images for dramatic effect or simply because it is cheaper than printing color. Since few people are still shooting black-and-white film, digital tools are used to prepare color images for monochromatic reproduction. The simplest method is the Image : Mode : Grayscale option in Photoshop. This process is fast, but offers no straightforward way to alter relative color values so that they transfer attractively into black and white. The Convert to B&W Pro plug-in provides an easy-to-understand method to achieve tonal characteristics that best fit the image. The program allows precise control over exposure and contrast that mimic conventional darkroom controls.

This image (left) is in need of correction for barrel distortion. (The bowed vertical rod has been colored red for clarity.) The PhotoFixLens dialogue box (right) affords separate, precise control of vertical and horizontal barrel and pincushion distortion as well as vertical and horizontal perspective.

An array of some of the effects that can be generated by the nik Color Efex Pro suite of digital filters.

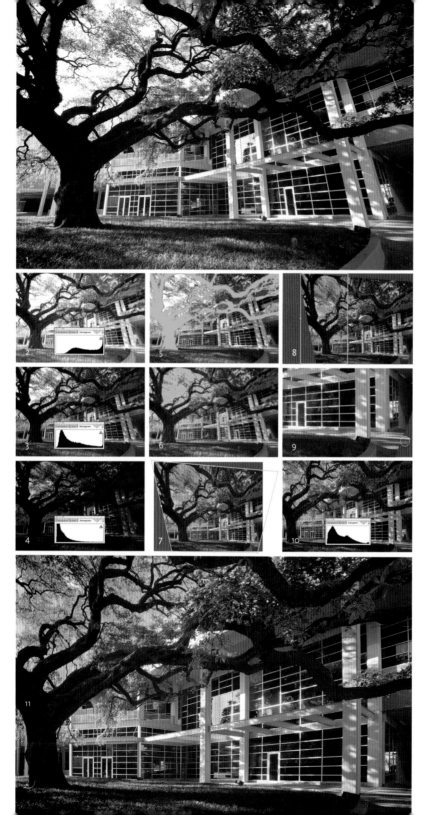

3–6 THE DIGITAL WORKFLOW FOR ARCHITECTURAL PHOTOGRAPHY

My digital imaging workflow involves the following steps:

• image capture, back-up of raw files
• raw file conversion
• preliminary sharpening
• establishing manageable dynamic range
• brightness, contrast, color correction
• image clean-up
• geometric control
• creative sharpening
• cropping
• sizing
• noise reduction
• output sharpening
• back-up of final files.

IMAGE CAPTURE AND BACK-UP

After a shoot, I duplicate my raw files as soon as possible, copying them from the CF card(s) to a laptop or desktop computer and also to a portable hard drive.

RAW FILE CONVERSION

The conversion of a raw file into a universal format such as PSD or TIFF is a critical process in the sense that it is important to make sure that all information arrives intact. That being said, achieving complete mastery of raw file conversion is impractical and ultimately unnecessary. My approach is to set the processing parameters of the raw converter as wide as possible, converting the file without altering the exposure, contrast, color, sharpness, and image size as recorded by the camera or scanner. After this is done, I archive the original raw file and then import the processed file into Photoshop for further refinement.

PRELIMINARY SHARPENING

Our perception of visual detail in the real world is a convincing illusion created entirely in the mind. Even though many photographic

1. The raw file as it came from the camera, in this case a Canon 1DS MKII fitted with a 17–40-mm wide-angle zoom lens, set to 17 mm. It is the exposure that the camera recommended—a reasonable compromise that sacrifices dark and light tones at both ends of the tonal scale.

2, 3, 4. Bracketed exposures (with histograms) made to recapture the missing tones from the average exposure.

5. I used the Magic Wand to select the darkest tones in image 1, feathered by 5 pixels. The selected areas are highlighted in green for clarity. Image 2, with lots of rich detail in the darker areas, was selected, copied, and then pasted into the selected areas. I used Levels to set a pleasing balance of tones.

6. Next I selected burned-out highlight areas in the new composite image with the Magic Wand, feathering the selection by 25 pixels. Image 4, with lots of rich detail in the highlights was selected, copied, and pasted into the selection in our growing composite image. I adjusted the brightness of the imported highlight with the Levels tool for a pleasing match with the overall image.

7. In step 7 the wide tonal range composite is corrected for perspective distortion. I set the canvas color to red so that the effects of the Distort control could be more easily seen.

8. A local correction makes the trunk of the tree somewhat thinner. After selecting the portion of the image demarked by the light blue rectangle, I applied the Scale control on the horizontal dimension.

9. Now the image is cropped to form a conventional rectangle. The triangular void in the lower right-hand corner of the frame (due to the earlier Distort operation) must be filled in with the Clone tool.

10. The last step is to tweak the overall color and tonal distribution with iCorrect. A bit of sharpening is applied as well. The histogram shows that the final composite image encompasses the whole tonal range, from light to dark.

11. The final image.

processes are capable of recording detail well in excess of what the eye can register, photographs on paper or on a monitor need to be somehow enhanced in order to match our expectations. This is necessary because the brain perceives a print or a screen as a two-dimensional object and so does not apply the corrections—the mental sharpening—it automatically applies to three-dimensional views. All digital sharpening methods make adjustments to the tonal gradient at the junction where areas of different brightness or color meet. This is called edge sharpening. The PhotoKit Sharpener plug-in, accessible through File : Automate from the top toolbar in Photoshop, provides a long list of sharpening tools tailored to a surprising range of film/scanner combinations and digital camera formats, which all yield images with different edge-sharpness characteristics. This first round of sharpening addresses subtle deficiencies in the capture process. It is done early in the workflow because these deficiencies can be amplified or distorted by subsequent Photoshop operations. If the PhotoKit Sharpener plug-in is not available, you can perform preliminary sharpening with Photoshop's Unsharp Masking or Smart Sharpen. Always use a bit less sharpening than looks good to you on the screen. Although the technology is improving rapidly, most monitors present a relatively crude representation of the working file and it is easy to miss the deleterious effects of oversharpening.

DYNAMIC RANGE

There are literally thousands of image control options available in Photoshop, but the techniques I use the most have to do with managing tonal range, also known as dynamic range. Dynamic range relates to the breadth of tonal information in an image from the highlights to the shadows.

Tonal range is a big issue for architectural photographers. A typical room may include areas of deep shadow, bright windows, and hotspots created by artificial lights. Exterior views normally encompass areas of open sky as well as dark and light surfaces made of glass, metal, stone, wood, or composite, all of which can be illuminated by shafts of direct sunlight interrupted

Two exposures were combined using only cut and paste in Photoshop in order to bring a full tonal scale wintertime exterior into this interior view.

by blocks of shade. We might do our very best to make the most perfect single exposure possible and still repeatedly fall short of an accurate one-shot rendering of reality.

 With some skill the dynamic range of interior scenes can be compressed by adding supplemental lighting, but this is time-consuming and costly. Outdoors, supplemental lighting is generally not an option. Presumably, sensor technology will continue to improve, but for now the most practical remedy to the problem is electronically extending dynamic range with software.

 I encourage the use of a tripod in order to guarantee image sharpness, but there is another advantage to tripod use that has to do with extending dynamic range. The technique involves making multiple exposures of a particular scene, bracketed 1 or 1.5 stops apart. At least three images are required, but five or more are useful in extreme situations. For our purpose it is best to vary exposure time only, since changing the aperture will alter the depth of field. If the images are made with the camera on a tripod, they will all be in perfect registration, meaning that they will all be framed identically. Each bracketed frame will have some tonal information that the others are missing. By combining this information electronically, you can construct a single image of very wide dynamic range. Photoshop provides a number of methods for combining images. Using layers and the eraser tool is one way, copying and pasting is another. I use a combination of these two for most of my work.

 Many interior views include a window in the frame. A wide series of brackets will yield a decent exposure for the room as well as a decent exposure for the landscape visible through the window. Two such exposures can be combined into one with simple Photoshop work: Select the darker image with the Select All command from the Select drop-down menu in the tool bar. Then, from the Edit drop-down menu, select Copy. Switch to the lighter image. Choose the Lasso tool from the left-hand tool bar. For a 25-MB image, set feathering at 50 pixels. Select the burned-out window area within the lighter image using the Lasso tool, navigating so that the selection occurs within an area of intermediate brightness between the overexposed window and the darker wall

This Photoshop screen shows a full tonal-range composite image of a San Diego living room lit by direct sunlight through several windows. On the right are the various layers holding image information culled from different bracketed exposures of the same scene.

or frame. From the Edit menu, click Paste Into. The two images will appear as one on the screen, but in reality, there are now two layers, each of which can be manipulated individually for color and brightness with the Curves and Levels controls by selecting each layer in turn from the Layers palette. The whole operation takes two or three minutes and is so effective that it virtually eliminates the need for remedial lighting for most interior views.

Once the two images are balanced to your liking, merge the layers by selecting Flatten from the drop-down Layers menu in the toolbar. (Make an interim save before flattening, in case you decide later that you do not like the effect.) You can then manipulate the composite image to achieve any global corrections required, including adjustments to perspective, color, sharpness, etc.

The copy/paste/merge solution described above is great for bringing natural-looking detail into simple, easy-to-isolate hotspots such as windows and light fixtures using two or three bracketed exposures. But the technique becomes unwieldy when a high-contrast scene is composed of complex patterns of light and dark across the frame. An easier way for handling such files is built into Photoshop CS2: Merge to HDR (High Dynamic Range) is an automated process for extending tonal range by electronically combining two or more identically framed but differently exposed images. The process begins with a series of bracketed exposures, as before. Convert the raw files to 16-bit TIFF or PSD files and open them in Photoshop. Choose File : Automate : Merge to HDR from the toolbar. The Merge to HDR preview window and dialogue box appear. On the left side of the preview window you will see a column with thumbnails of the bracketed images. A composite view of the merged images appears in the main window, and a bit-depth pop-up menu and a histogram with a slider beneath it appear on the right.

Photoshop is capable of handling the merge operation at a 32-bit depth, but this results in a gigantic final file. Since an 8-bit output will be sufficient for most purposes, select 16-bits from the pop-up menu. (The 16-bit merged image will be converted to an 8-bit file at the end of the process.) Next, slide the histogram slider

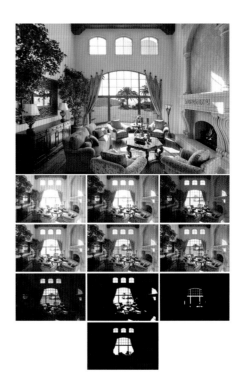

This series shows how a natural-looking interior view can be created—even in circumstances with extreme contrasts—without auxiliary lighting. On the bottom are some of the eight-stop brackets from which image information was harvested. The black-and-white high-contrast frames are the image masks that are created automatically whenever portions of images are selected with the Lasso or Magic Wand in Photoshop. They are used to cut and paste needed tonal information into the master file (top). The fire in the hearth was imported from another shoot. Note also that subtle local adjustments have been made to partly mitigate wide-angle effects.

left or right until the merged image looks right. Bracketed images can be added or removed from the mix by checking or unchecking the little boxes at the bottom of each thumbnail. The preview image will change to reflect this, with the rate of change indicated by the progress bar beneath it.

Once you have achieved a reasonable-looking composite, click OK. The HDR Conversion dialogue box appears. Select Local Adaptation from the pop-up menu and click the triangle next to the Toning Curve and Histogram. You can manipulate the toning curve to alter the merged image to taste. The histogram is used to set the dark and light extremes in the image. Set the sharpening parameters with the Radius and Threshold sliders. (Ignore this option if Photokit Sharpener is available.)

Click OK when you are satisfied and Photoshop will generate a high-dynamic-range final image that can be further enhanced just like any other image file. Once you have finished work on the file, select Image : Mode : 8-bits from the toolbar to create the final image for output.

BRIGHTNESS

After creating an image with a sufficiently wide dynamic range, I further refine tonal values by selecting Image : Adjustments : Shadow / Highlight : Advanced. In both the Shadows and Highlights windows I set the Radius sliders to 300 pixels. This ensures that tonal adjustments introduced by the Amount and Tonal Width sliders will be smoothly integrated into the rest of the image. I set the highlight and shadow densities by eye, leaving the Color Correction and Midtone Contrast sliders at zero. Shadow / Highlight is a powerful control that is easily overused. It is best to subtly lighten areas of deep shadow and to slightly enrich very bright areas.

CONTRAST AND COLOR CORRECTION

Pictocolor's iCorrect Edit Lab plug-in is very useful to set the black and white points, contrast, brightness, and neutral color balance (see page 52). But you can also adjust image brightness and image color by eye with the Levels, Curves, or Hue/Saturation tools built

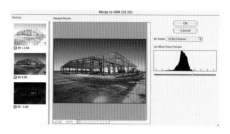

Photoshop's Merge to HDR function is extremely useful for creating very long tonal-range images from a series of bracketed exposures from scenes that are too complex for straightforward cutting and pasting.

into Photoshop. These controls are accessible from the Image : Adjustments menu. Levels and Curves alter apparent image brightness and contrast, while Hue/Saturation alters apparent image color balance and color depth. These commands are reversible because they are non-destructive—no tonal information is discarded when they are implemented. Photoshop's Brightness and Contrast controls, on the other hand, are not reversible and should be avoided; they permanently discard tonal information when implemented.

IMAGE CLEAN-UP

Next I meticulously examine the image in order to find and remove artifacts left behind by dust or other detritus on the sensor. For this I select the Cloning Stamp or the Healing Brush from the tool palette. The Healing Brush fills in bothersome elements with tonal information automatically fabricated from the surrounding pixels. The Cloning Stamp hides defects with user-selected information from an adjacent area or from elsewhere in the frame. You can also use this tool to remove larger objects such as misplaced light standards, trashcans, or even cars. (Use Cut and Paste in combination with the Cloning tool for dealing with larger objects or textured surfaces.)

GEOMETRIC CONTROL

I alter the dimensional aspects of an image only after I have finalized its tonal and color characteristics, because it is easier to import tonal information by cutting and pasting from identically framed bracketed exposures before the shape of the image is

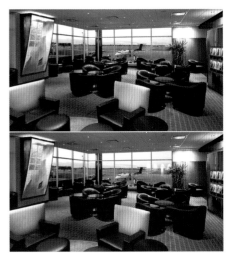

More often than not only modest Photoshop interventions are required to make an image presentable. Here reflections from sconces in an opposing wall (bottom) were removed with judicious use of the Cloning tool (top).

Perspective control is an issue inside as well as outside. Here a distorted reception desk, shot by necessity with an extremely wide-angle lens is, in stages, brought back into respectable rectilinearity. First I used the Distort control to align the verticals. The Scale function then brings back a more natural proportion. Finally, I filled in the voids in the corners created by the Distort/Scale process with a combination of copy and paste and cloning.

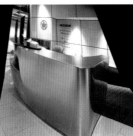

THE DIGITAL WORKFLOW

3–6 THE DIGITAL WORKFLOW
 IMAGE CLEAN-UP
 GEOMETRIC CONTROL
 CREATIVE SHARPENING
 CROPPING, SIZING, NOISE REDUCTION,
 OUTPUT SHARPENING

altered. Once tonal range has been properly balanced, geometry can be safely addressed. Whenever possible, it is best to correct perspective at the time of exposure. Final corrections can be accomplished in Photoshop, provided the image is of sufficiently high resolution.

To achieve geometric control over an entire image choose Select All and then Edit : Transform from the toolbar. The transform menu provides a variety of operations including Scale, Rotate, Distort, Skew, Perspective, Flip Horizontal, and Flip Vertical. The Perspective tool varies the overall horizontal and/or vertical recti-linearity of an image in one operation. The Distort tool alters left, right, top, or bottom rectilinearity individually. After I have lined up the overall image appropriately, I remove any barrel or pincushion distortion with PhotoFixLens.

I also work on selected areas inside the frame with the Scale and Distort controls to individually alter the shape of smaller image elements that appear misaligned due to an unusual point of view or an extreme wide-angle lens. Adjustments to the shape of a light fixture or a piece of furniture will often leave voids in the image that can be filled in using the Cloning Stamp. Photoshop CS2 incorporates tools for image alignment according to perspective and vanishing point information.

CREATIVE SHARPENING

Creative sharpening with Photokit Sharpener, or with Photo-shop, is applied in a way that is mindful of the textural quali-ties of a given image. For example, we expect broad areas of sky to have a very subtle textural modulation. Sharpening the sky would threaten its smoothness and result in an image that looks fake. On the other hand, a building made of brick is not at all smooth, and the appropriate application of local sharpening to the bricks will authenticate and enhance our visual experience.

CROPPING, SIZING, NOISE REDUCTION,
OUTPUT SHARPENING

I implement these straightforward mechanical operations after the tonal and aesthetic aspects of the digital image are under

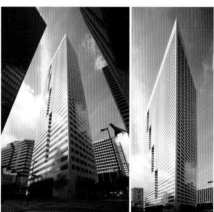

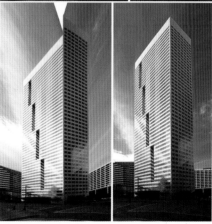

This Houston skyscraper was photographed close-up from street level with my widest lens, a 14-mm L Series Canon. Extreme maneuvers in Photoshop were required to render a final rectilinear image. Note the severe "ship's prow effect" that has been addressed by splitting the image down the major vertical composition line, and then altering each half of the image separately. The final image is presentable, but only about 25 percent the size of the original uncorrected image.

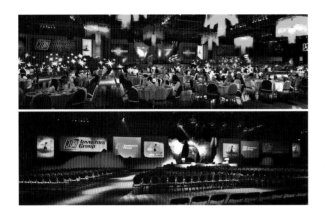

Some images are weakened by conventional frame proportions. Be bold and create wider or taller formats by cropping decisively where appropriate. These two images were made with a special panoramic camera, but a similar effect can be achieved by simply cropping a regular image, as long as the original image has enough resolution to sustain an aggressive crop. The two photos shown here would have been much weaker if more ceiling or foreground had been included in the shots.

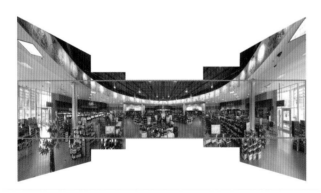

This extreme panorama was made using the extreme shift technique with the 24-mm Canon Tilt/Shift lens, but with the addition of two more images made by rotating the tripod head to the left and right. The shape of these two shots was altered using the Distort control in Photoshop in order to match up geometrically with the adjacent images.

This high-resolution image (90mb) of Arthur Erickson's Waterfall Building in Vancouver was assembled from the four images on the right: Upper and lower images were created by shifting the 24-mm Tilt/Shift Canon lens to its vertical extremes with the camera fixed on a tripod. The pair in the middle was exposed for shadow detail and the pair on the right for highlight detail. Upper and lower images were joined in Photoshop and then shadow and highlight detail enhanced as required.

control. Cropping is a powerful aesthetic instrument because changing the shape or size of an image alters our emotional and intellectual reaction toward it. Cropping is also a significant design tool for book and magazine editors, designers, and art directors who need to create dynamic, informative, and accessible layouts in their publications.

Chapter 4, which deals with scanning technique, describes the process of sizing images according to end use.

Noise Ninja recommends a noise reduction scheme by generating a noise "profile" from the image being processed. You can download specific noise profiles for a long list of cameras and scanners from http://www.picturecode.com/profiles.htm.

Photokit Sharpener provides menus accessible through File : Automate that offer a range of output sharpening levels appropriate to image size, paper quality, printing method, and printer resolution.

Cropping is an art. Here a photograph pegged well into the twentieth century by the inclusion of the relatively modern steel pump within the frame (right), is regressed about fifty years by a simple crop (left). The image composition is also more pleasing in the simplified version. These photos were produced for an anthropologist documenting the hand-made habitations of early Mennonite immigrants to Central Canada.

CREATING A PANORAMA IMAGE

To build an extremely wide, perspective-controlled image, set the camera on a tripod and make two exposures with the wide-angle PC lens shifted to the horizontal or vertical extreme. Combine the two images using cut and paste in Photoshop; clean up the boundary line with the Clone tool.

More complicated panoramas can be created with Photomerge (accessible through File : Automate). This tool will automatically knit two or more images together into one. Shoot the images from the same distance away from the subject and at the same exposure settings. The process works best if each image overlaps the next by about 25 percent on the common side(s). You can build even more sophisticated panoramas, up to 360° wide, with multiple images and specialized software such as Panorama Factory (http://www.panoramafactory.com/) or Realviz Stitcher (http://www.realviz.com/).

4 SCANNING

Despite the digital revolution, many people still sit on large archives of old negatives, transparencies, and prints that need to be integrated into their new digital library. A scanner is the most versatile interface between conventional film and computerized image handling.

4–1 HARDWARE

There are three types of scanners available: flatbed scanners, slide (or film) scanners, and professional (very expensive) drum scanners. Any decent flatbed scanner can reliably resolve 2,400 DPI over an 8.5-by-11-inch surface, but slides and negatives are much smaller and consequently must be magnified for reproduction, requiring significantly greater resolving power at the scanning stage. Dedicated film scanners are capable of resolutions up to 4,000 DPI and come equipped with reliable holders to position film firmly and precisely. The prices of high-quality used scanners have plummeted right along with the price of used high-end film equipment.

4–2 SCANNING TECHNIQUE

All scanners come with software for managing color balance, brightness, contrast, image cropping, image size, and image resolution. The skilled operator will use these controls to render the most useful raw scan that the scanner is capable of producing. It is important to note, however, that a raw scan, no matter how well made, will be used directly for reproduction only very rarely: some Photoshop work is usually required to refine a raw scan into a file that is a serviceable fit with the ultimate reproduction medium, be it photo paper in a desktop ink-jet printer, archival vellum for high-resolution lithography, or a computer screen linked to the Internet. But even Photoshop cannot really fix a bad raw scan, so it is important to have a basic understanding of how scanner software controls affect output.

The preview function—a fast, low-resolution scan that yields enough detail to form a reasonably clear image on the screen—is used to set and judge scanning parameters. Obviously, the state of the computer monitor is an important variable in this operation. Calibrating a monitor for exact standardized tone and color reproduction is relatively easy these days. Several manufacturers provide software and sensors for this purpose (see page 48).

Brightness and contrast adjustments can be made with the controls available as part of any scanner software program.

The Minolta Dimage Pro scanner is a competent device for generating high-resolution files from 35-mm and medium-format film.

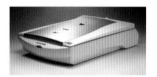

A typical flatbed scanner

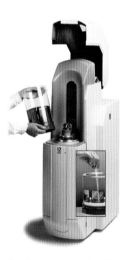

The drum scanner is the ultimate tool for capturing digital image information from film. On the unit pictured here the optically transparent drum holding the film to be scanned is about to be mounted. Some drum scanners have horizontal drums, but here the drum orientation is vertical. The insert shows how an optically transparent fluid is used to ensure close contact between the material to be scanned and the inner surface of the drum. This is done to eliminate Newton's Rings, an optical aberration caused when two almost perfectly smooth surfaces are brought very close together.

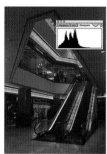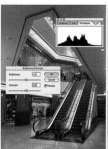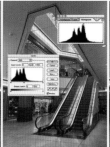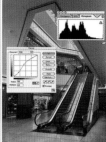

These simple tonal tools work in a linear fashion—if an image is made brighter or darker, every point in the image is made uniformly lighter or darker at once, and tonal values that exceed the system's recording ability disappear irretrievably. Similarly, if the contrast of an image is increased, information about both highlight and shadow detail is lost in one stroke.

A more sophisticated approach is available with Levels and Curves, which are non-linear controls built into most scanner software and Photoshop. In Levels the maximum highlight and minimum shadow values are set to the maximum and minimum recordable values for the hardware; then in-between gray-scale values can be altered to make dark areas lighter or light areas darker as required by moving a virtual slider along a histogram while observing the changes in the program's preview window. Contrast adjustments, which are not recommended at the scanning stage, are rarely required once this operation is properly done. Curves controls work in much the same way, except the tonal map is presented as a two-dimensional graph and adjustments are made by moving virtual points on the tonal curve.

Color control is best achieved with the Levels or Curves approach as well. The goal at the scanning stage is to get all of the useable color information in the original image into electronic form. Level and Curves controls are typically available for the individual red, blue, and green color channels that the scanner records, so a color caste (a color bias or color shift) can be corrected while preserving the maximum tonal range with a minimum of data loss.

Resolution is the next consideration when producing a raw scan, and for best results it is important to consider the end

This series illustrates what can be done to a typical raw scan (left) using the Brightness and Contrast controls (second from left), the Levels control (center), and the Curves control (second from right). All these interventions make the image look better in some way, but the alterations are quantitatively different. The Brightness and Contrast controls move all image density information at once, so that the middle tones appear brighter, but highlight information at the upper end of the tonal range is permanently discarded. The Levels control brightens the image by moving the middle-brightness-range pixels while retaining all shadow and highlight details with no change in image contrast. Of the three approaches, the Curves control is the most sophisticated, since it allows non-destructive alteration of tonal distribution across the entire brightness range. Even so, no single operation on tonal range will take a complex image to completion. The image on the extreme right has had its tonal range and color balance carefully adjusted using the Levels and Color Saturation controls in selected areas in addition to global corrections with Shadow/Highlight and iCorrect. The perspective alignment was fine-tuned with the Distort control. The final operation was global Smart Sharpen set to .9 pixels and 100%.

use of the image. The scanning process digitally deconstructs a continuous-tone image into an electronic file that assigns numerical gray-scale and color values to a network of virtual dots positioned on a virtual grid. The finer the grid, the more dots are required. The amount of detail recorded during the scan and the amount of detail visible upon reproduction is described qualitatively by the term *resolution*, but resolution is quantified in different ways for different media. For example, the dots on the grid pattern employed by an inkjet printer are actually called dots, so resolution is described in terms of dots per inch, or DPI. The dots associated with a digital camera or a computer screen are called pixels, and in this case resolution is described by pixels per inch, or PPI. The dots associated with the scanning process are properly called samples, and scanner resolution should be described as samples per inch, or SPI. The popular convention uses DPI, however, rather than SPI for scanner and scan specifications, even though common sense tells us that there can be no such thing as a dot in cyberspace. (Virtual dots in cyberspace are described in terms of bits and bytes.)

We tend to think automatically that more is better, but this is not true for scanning and scaling up or down—the process of creating appropriately sized image files for reproduction purposes. For many common uses, the maximum resolution of most scanners far exceeds the requirements of the reproduction techniques being used. Too much digital information can overwhelm the computer or the printer farther down the line, leading to computer crashes, very slow output times, and slow downloads from the net. The scanning resolution should therefore be limited to match the final reproduction medium.

Consider the example of an 8x10 photograph that is to be scanned on a flatbed scanner, manipulated in Photoshop, and then printed out to one half its original size with a photo-real inkjet printer. If the scanner is capable of 2,400 DPI, a scan at maximum resolution will create a file of 2,400 DPI x 10 inches x 2,400 DPI x 8 inches = 460.8 MB. That is a lot of data. Now let's look at it from the perspective of the final print-out. A good ink-jet printer is easily capable of printing 1,440 DPI x 720 DPI, so a 5x8 picture

These four images show the effect of scanning at different resolutions: 20 DPI (upper left), 72 DPI (upper right), 150 DPI (lower left), 300 DPI (lower right). As the numbers increase it becomes harder to visually detect an increase in resolution due to the limitations of the lithographic process used to reproduce the images on this page. This effect is of course related to the magnification. If these images were printed smaller on the page, the difference in resolution between them would virtually disappear.

printed out at maximum resolution would require 1,440 DPI x 8 inches x 720 DPI x 5 inches = 41.47 MB. This is only a tenth of the image size we calculated earlier—a substantial difference. But there is another consideration: at normal viewing distances the naked eye cannot distinguish any significant difference between an image printed at 300 DPI and an image printed at 720 DPI, let alone 1,440 DPI. So for our purposes, a 300 dpi x 8 inches x 300 DPI x 5 inches = a 3.6-MB file, is sufficient, less than a hundredth of the scanner's maximum resolution capabilities. To achieve better detail, scan the original at twice the resolution required by the output device and then scale it down to the final size. At the scanning stage, therefore, the software should be set up to scan the original 8x10 print at 300 DPI, resulting in a 7.2-MB file, which we will scale down in Photoshop to 3.6 MB before printing out the 5x8 image. A 7.2-MB file is relatively tiny, and consequently easy to process, compared to the nearly half-gigabyte (1G = 1000 MB) file that the scanner would have produced at maximum resolution.

Scaling down results in a proportionally smaller print with the same resolution as the original, unscaled file. Scaling down maintains final image integrity by eliminating data that is unnecessary for printing: fewer dots are required to make a smaller print. Going up in scale is an entirely different matter: image integrity is not preserved when a file is scaled up. In this instance the new data required to cover the increased image area is created by software interpolation, quite literally filling the space between the original dots. The invented dots are assigned color and density values by averaging the values of the existing dots around them. The resulting print is smooth in tone, but will contain no more (and often somewhat less) detail than the original unscaled file.

5 AESTHETIC CONSIDERATIONS

"Photography" means drawing with light. A true understanding of the craft begins with an appreciation of the variable qualities of light: color, intensity, direction, and specularity. Of these four qualities, specularity is of critical importance for architectural photography.

Specularity is a function of the size of the light source in relation to whatever is being illuminated. For example, the sun on a cloudless day is a highly specular, or hard light source, while an overcast

sky is a non-specular, or soft light source. An object illuminated by a hard light throws a shadow with precisely defined edges. The shadows from a soft light source are fuzzy and undefined.

The manner in which light strikes a particular object, and the way in which the surfaces of the object alter the characteristics of the light, trigger emotional reactions in our brains. Unlike other visual artists who are free to create whatever light they need with paint or pencil, photographers must collect light from nature. Since nature cannot be manipulated or controlled, much of the skill involved in photography has to do with the patient observation of changing conditions, good timing, and good luck. There is no mystery to this; the only requirement is a willingness to pay attention.

5–1 THE SKY, THE SEASONS, AND TIME OF DAY

Daylight is the primary source for most exterior architectural views as well as many interiors. The position of the sun in relation to an architectural subject depends on the situation and orientation of the building on the surface of the planet (longitude and latitude), the time of day, and the location of the Earth in its yearly progression around the sun (the season). In fact, the photographic evaluation of a particular site is a parallel effort to the sun study that would have been done by the architect when the building was designed.

The design and texture of a given building will dictate the sun angle best suited for a powerful image. If the photograph is required quickly, the time of day will be the only variable. When the need is less urgent, it is quite sensible to wait for weeks or months until the sun moves to some optimum location.

5–2 LIGHT INTENSITY AND COLOR

Within an image the relative brightness levels of various elements is significant. Both direction and specularity of light have a bearing on image contrast, and image contrast in turn has an emotional impact. For example, hard sunlight falling from an elevated angle upon a starkly fashioned stone facade results in a deeply chiseled

These three photos show how color temperature contributes an emotional note to every photo. Particularly telling is the picture of the home with the Christmas lights: here, using color as the main instrument, a cozy, enchanting realm is created inside a frosty, somewhat forbidding winter landscape.

Bold, monumental forms demand bold specular light. The much-bigger-than-life concrete buttresses on this concert hall in Houston are sharply delineated by low-angle, early evening sunlight.

image with dark shadows and brash highlights; the monumental constructions favored by the Nazis were always portrayed in this way. The same structures illuminated by softened, diffused light coming from a low angle lose some of their garish, authoritarian overtones.

Color enhances the mood evoked by the sculptural influences of sun angle and specularity. The color of light is described precisely with the Kelvin color temperature scale. So-called "normal" daylight measures 5,500° Kelvin but the color temperature of daylight varies according to time of day, time of year, geographical location, and air purity. A sunset at the end of a dusty prairie day would radiate very warm light, perhaps as low as 2,500°K, while high noon up in the Rocky Mountains could register a very cool 20,000°K.

There is in each of us an unconscious impulse to impose a "natural" color balance on everything we look at. We seek out familiar visual clues such as skin tones, blue sky, or leaf green, and automatically rearrange the images we perceive so that these color markers fall within a normal, or comfortable, range. This is easily demonstrated: a room lit by warm tungsten light seems natural enough when seen from inside, but the same room, viewed from the outside at dusk, looks extremely yellow. Standing outside we quickly become acclimatized to the ambient light condition, which is typically much cooler than the artificial tungsten light. This phenomenon is not simply a matter of relative color, it is an actual shift or tilt in perception.

The emotional power of color comes into play whenever the brain tries to "correct" color balance: slight corrections alter one's mood very subtly while gross discrepancies that are beyond the capability of the brain to compensate result in very strong responses. Even the vocabulary we use to describe color conditions (i.e. warm, cool, neutral) attributes an emotional weight to them. Since the color response of photographic recording mechanisms is subject to manipulation, the color balance of a photograph can either accurately track what is offered in nature or embellish it.

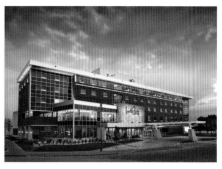

This complicated facade photographed well in the glow of a cloudy evening twilight. The photo was taken as soon as the ambient light diminished to the point where the building's internal and external lighting began to predominate. I later increased local contrast and color saturation in the cloudy sky in Photoshop and darkened and smoothed the sidewalk and roadway in the foreground. I also used Photoshop controls to do local sharpening on the bricks and stonework.

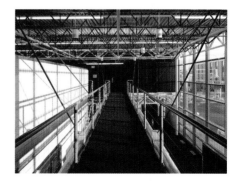

Warm, nearly horizontal sunlight at sunset in a northern Manitoba mining town turns this government office building into a complex shadow box. Here the unique sun angle and the warm color temperature give the scene an appealing glow. Note that even the black commercial carpet retains some texture on account of the raking light.

5–3 POINT OF VIEW AND IMAGE COMPOSITION

In photographic terms, point of view is a physical position from which something is visually considered, evaluated, and experienced. An asymmetrical three-dimensional object looks different from every different point of view. Similarly, the same object looks different in a two-dimensional photo made from a particular point of view than it looks to the human eye from that same position. Because we react to photographs emotionally as well as rationally, a variety of photographs made from a variety of points of view feel different because they look different. The photographic point of view, therefore, is a point in physical space relative to the objects we record as well as a point in emotional space.

 In urban contexts we usually do not have an infinite range of shooting positions, but there are still many to choose from: a practical point of view might be found on the street, up a ladder, on a fire escape or a rooftop, at a window, or even aboard a hovering helicopter. Each choice carries emotional implications: We look up in awe, down in disdain, level in equanimity. We can be critically close or dispassionately far.

 Much architectural photography is done with the camera positioned at eye level, a condition that to most people simply means a point of view that seems natural. But there are a range of possible "eye levels," the two most common associated with standing and sitting. Architects incorporate other eye levels into their work; the view from an elevated walkway through an atrium, for example. Some photographic impact can be achieved by working against the expectations normally associated with natural points of view by shooting very close to the ground, or shooting from high up. Such choices can result in images that have a playful, spontaneous feel, but they can just as easily be awkward, sinister, or just plain goofy.

 A clamping device extends the range of usable camera locations. I use a vise-grip pliers with a tripod head attached to secure cameras to ladders, stairways, and banisters. Elastic bungee cords can be used to steady camera/tripod combinations that have to be jammed into odd positions near railings, posts, parapets, or vehicles.

Sky conditions, season, and the time of day all contribute to the photographic qualities of sunlight at any given moment. They all played an important role in building this unique image. The frozen landscape pictured here could only have been made in winter, of course, but the season contributed more than just a frigid temperature: the sun is low in the sky at northern latitudes during the cold months, so bright noon-time winter sun provided very sharp modeling of the white and near-white textures in the snow and ice.

Camera stability is essential for maximum image sharpness and for reliable image registration whenever multiple exposures are combined to extend tonal range, so I use a tripod with a cable release for most of my work. A tripod head that is attached to a vise-grip welding clamp makes it possible to secure the camera to stairway banisters, etc., when required for particular points of view.

The process of finding a unique point of view is a lot easier with digital hardware, which is light, fast to set up, and so ordinary-looking as to be generally unobtrusive—a decided advantage in post–9/11 North America.

Volumes have been written on the theory, process, and implementation of good image composition. But I am no art scholar; my approach to image composition is purely intuitive. What I do know is that architecture is created with care so that function and form are harmoniously married. Architecture is sculpture on a large scale—sculpture that can be lived in by human beings. In my view, the job of the architectural photographer is to study what has been built and report back to interested viewers with photographs that are accurate, accessible, and attractive in their own right.

Three very different points of view, all made with the same lens, a moderate wide-angle PC lens. The image on the far right was made using a vise-grip welding clamp equipped with a tripod head that allowed the camera to hang out over the upper banister. This yields a view that suggests the camera was suspended in mid-air.

6 EXTERIOR ARCHITECTURAL PHOTOGRAPHY

In the studio, the commercial photographer creates a scene in which the lighting and the camera position are optimized to best portray the subject. When working outdoors with subjects of monumental scale, virtually all controls except for choice of camera position and the time of day are eliminated.

6–1 SELECTING THE ANGLES AND TIME OF DAY

Finding the right camera position and angle of sunlight is a Zen-like process of observation and surrender—surrender to both the workings of nature and the design of the building and its surroundings.

A site inspection, preferably in the company of the designer, is essential. The first efforts should be directed at finding suitable views from eye level, below eye level, and above eye level. The higher vantage points might be located on nearby buildings or hills, while the lower vantage points might require a bit of crawling around. Glass- or metal-clad buildings are tricky because different perspectives invoke different reflections that will impact image composition. Fine-tuning the final point of view involves very precise camera movements of a few inches to a few feet to balance the interaction between small but significant foreground details such as trees, lamp-posts, or street-signs, and elements of the building's facade.

This series of photos depicting Corbett-Cibinel Architects' new Environmental Safety Building at the University of Manitoba illustrates a range of points of view. Each different point of view requires a different lens for appropriate subject coverage. These images were made with the Canon 1DS MKII 16.7MP camera and a range of lenses from extreme wide-angle (17mm) to extreme telephoto (300mm). All the photos were taken during a two-hour session that began just a few minutes before sunrise.

Next, decide what angle of sunlight will be most effective. A simple rule says that coarse-skinned buildings (wood, brick, cement, stucco) are best highlighted by steeply angled direct sunlight, while smooth-skinned buildings (glass, metal, tile) are enhanced by reflected light, such as that from an attractive sunrise, sunset, or cloud formation.

6–2 OPTICAL CONSIDERATIONS

Except for the recording of details and shooting at a distance, most architectural photography depends heavily on wide-angle lenses. Strictly speaking, each different point of view around a given site will demand a lens of different focal length; inevitably, you must sacrifice or modify some desirable points of view because the perfect lens is not available.

Moderate wide-angle lenses can be trusted not to exaggerate perspective to an unmanageable degree and can be used both dead-on and from acute angles. The dimensions of the subject and the lenses' angles of acceptance geometrically predict minimum working distances. Extreme wide-angle lenses are problem-solvers in tight circumstances but they have a very narrow comfort zone and consequently must be used carefully.

6–3 HOW TO SHOOT LOW-, MEDIUM-, AND HIGH-RISE BUILDINGS

Low-profile buildings are the least technically demanding to photograph. Generally, moderate wide-angle or normal lenses can be used to shoot rectilinear elevations and oblique views. The problems in this case are more aesthetic than technical, since many low-budget industrial or suburban strip malls are very plain.

Add some visual interest by using the building's architectural embellishments, however unprepossessing they might be, to advantage. Most multi-tenant structures will have some kind of stand-alone signpost or marquee that you might include as a foreground element to break up the oppressive horizontality of a suburban/industrial landscape. The front wall of most low-rise buildings will have some decorative texturing, such as brick,

Glancing sunlight and a wide-angle lens work together to emphasize the stucco and brick textures in this shot.

stained wood, or exposed aggregate, which can become the image's compositional focus. To achieve this, shoot the embellished surface from a close distance at an angle along its length with a moderate wide-angle lens. The effect is enhanced by a glancing sun angle. (An extreme sun-angle can be pitilessly revealing of mechanical flaws. Choose a more modest angle when shooting imperfect finishes.) If a PC lens is available, shoot from a lower-than-eye-level camera position to add to the sense of drama. Even without a PC lens you can choose this point of view when photographing low structures—align the camera for proper perspective and crop out excess foreground later.

Since strongly horizontal images allow for a broad expanse of sky, make your photographs on a day when interesting cloud formations are visible. Sky tones can be enriched with a polarizing filter. What might otherwise be simple, documentary-quality images of very plain structures can sometimes be improved by shooting around dusk or dawn; warmly colored reflections will embellish rows of windows that would appear grimly monotonous in broad daylight.

A bird's-eye-view of a low-rise building can make an effective photograph. Low-budget structures generally have only tar, gravel, and ventilation equipment on the roof, but more elaborate structures often feature more attractive finishing as well as

This image of a new Hilton Hotel—shot during a Winnipeg winter—was improved by adding a sky harvested a year earlier during a sunrise on the Ganges River in India. The result ended up as a large banner in the Winnipeg Airport. Note the signage on the building: I copied a printed logo from a sample of Hilton stationary and then inserted the Photoshop-enhanced results into the new composite image.

Serendipitous reflections can enhance even very modest images. The horizon line reflected in this tract-home window was positioned just so by selecting the right camera position.

greenery around the buildings. From an elevated point of view, such as a nearby rooftop or balcony, a photo of the whole site might be quite attractive. If no elevated vantage point can be found nearby, create your own. It is surprising how different things look from the top of an eight- or ten-foot ladder or a cherry picker. (You can rent these machines for about $75 an hour with an operator.)

Low buildings are often surrounded by oil-stained driveways and parking lots. If you cannot eliminate the negative visual effects by cropping the image, include a few clean, late-model cars in the composition as camouflage. (For ground-level shots use a slightly elevated camera angle so that the cars do not unduly obstruct the view of the building. I sometimes extend my tripod to maximum height and stand in the trunk of my car to get access to the camera.) When an unsightly foreground simply cannot be avoided, judicious Photoshop retouching can help. You can use Photoshop to deepen the color of a pale or overcast sky or import sunsets, sunrises, or interesting cloud configurations from your collection into needy images. Unsightly reflections in windows can sometimes be replaced electronically with imported views of clouds, a sunrise, or sunset panorama.

The same techniques suggested above also work for photographing medium-rise buildings, although it will be more difficult to shoot close up and at lower angles without PC lenses and a full-frame DSLR. Structures of several stories are often built better than those of only one or two stories, so it is likely that finishing and landscaping are superior. Choose angles that highlight these elements to improve your photos. Taller buildings usually have a lot of windows so reflections of interesting cloud and light conditions can figure prominently in your compositions. If the reflections from particular angles are distracting, a polarizing filter can sometimes attenuate or eliminate them altogether. Whenever windows are prominent, take the time to go from room to room and arrange blinds and drapery so that they appear uniform and tidy from the outside.

It will likely be necessary to get above street level in order to avoid converging verticals. If the neighboring structures are

This photo of a renovated Sears store was commissioned in midwinter. Sears management decided to use it on the cover of their annual report, but wanted the snow to go away: the result took about three hours of Photoshop work.

A nighttime interior and a daytime exterior are both enhanced by compositional elements in the form of reflections. The effective incorporation of reflections in this way requires very precise camera positioning.

too tall, shooting from a rooftop will cause the same problem in reverse: diverging verticals. The solution is to shoot through a window at mid-height. Results will be best if the windows open, but often they are permanently sealed. In this case, a few precautions are necessary: First, turn off all the lights in the room to avoid distracting reflections. To further reduce the possibility of reflections get as close to the glass as possible; in fact, it is best to have the lens actually touch the glass surface. (If you use this method, first ensure that the glass does not vibrate with passing traffic or activity within the room. A soft rubber lens shade will effectively isolate the camera from vibrations in the latter circumstance.) A tinted window will induce a color cast that must be corrected in Photoshop. Clean the outside of the window if it is accessible.

High-rise buildings are difficult to photograph well with DSLR equipment. The main task is an exercise in photographic detective work since a good combination of shooting and sun angle that does not require extreme perspective correction is often hard to find. The problems associated with this search are as much diplomatic as they are photographic. Since most of the useful viewpoints will be found inside or on top of neighboring high-rise buildings you will have to negotiate with building managers, security guards, and maintenance people. It may be necessary to arrange in advance for written permission to access certain buildings, and you may have to pay for a security person to escort you.

Once on location, be prepared for some unusual mechanical obstacles. Vertical metal ladders, narrow walkways, and restricted parapets are typical on top of tall buildings. Some physical contortion and/or creative clamping may be necessary to secure the camera properly. Extremes of temperature, wind, and vibration are problematic up high, as is air quality. Both urban smog and natural haze can stain or obscure an otherwise decent sightline, although polarizers or ultra-violet filters are sometimes helpful in improving image contrast and color. As a rule, high-rise photography is slow-going. A few hours of work might yield only three or four good images.

Aesthetically speaking, photographing tall structures involves difficulties not unlike those presented by very horizontal

These days a polarizer is the only optical filter I carry. It has the power to reduce reflections from many surfaces, including water, glass, and foliage. In addition, polarization increases color saturation and sometimes can dramatically darken the sky. All these elements are obvious in the polarized image (right) of this pair of otherwise identical shots. Note the richer sky and the much clearer view through the window glass. On the negative side, some materials appear strangely distorted when viewed through a polarizer: this is true for the vertical glass flags in the polarized image. Instant digital feedback via LCD or computer screen is helpful in avoiding unattractive results. In this case, the increased transparency of the windows was welcome, while the strange modulations in the glass flags was later reduced in Photoshop by locally desaturating the color.

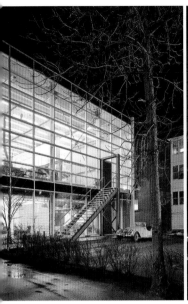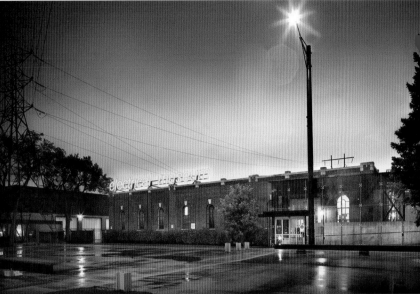

structures, with the added complication of contextual clutter. Wide but low buildings allow the use of the sky as a compositional component, but tall buildings are usually found in the company of other tall buildings and there is no guarantee that they will appear side by side in harmonious configurations. Persistence may pay off in the discovery of a location that reveals the building of interest nicely nestled within a framework of other structures or spotlighted by a serendipitous shaft of sunlight.

From close by, the facade and the first few floors of skyscrapers can be photographed while maintaining parallel verticals but to capture the whole height of the building usually means tilting the camera. The exaggerated views afforded by extreme wide-angle lenses are sometimes welcome in these circumstances, particularly if there is a nice-looking entrance, corporate logo, or piece of sculpture that can be incorporated in the lower foreground.

The exact time of day is critical. The shadows of deep urban canyons retreat for only minutes at a time. Skyscrapers act like giant sundials and darken each of their neighbors in turn as the daylight hours pass. Since modern buildings are often clad

Wet driveways and parking lots hide unsightly oil stains. At night they look even better. On the right, a brief shower provided the moisture, while on the left a few minutes' work with a garden hose did the trick. The door, car, stairs, and tree in the left-hand image were lit with the painting-with-light technique (see page 108), using a hand-held 1000-watt tungsten photo light.

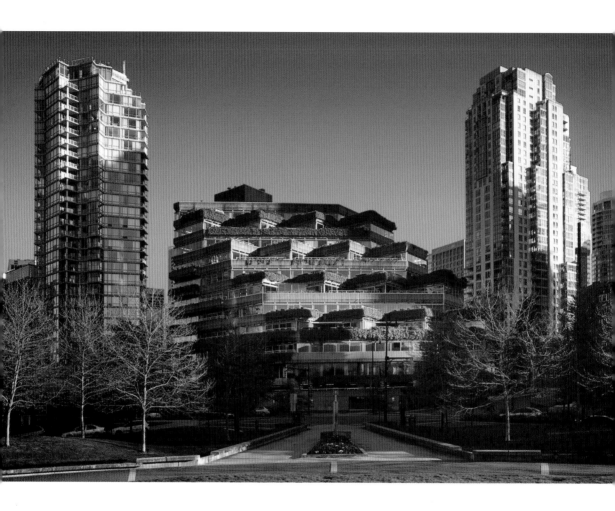

Here are two examples of what I call the "urban sundial effect." As the sun moves across the sky, shafts of illumination sweep the city skyline. By anticipating where light will strike and when, one can be ready at exactly the right location with the right lens to make the shot at exactly the right moment. On the left, the brightly lit facade of Arthur Erickson's green condominium in downtown Vancouver is bracketed by buildings in relative shadow. On the right, a heritage building in Houston is lit by a serendipitous sunbeam through a hole in a swiftly moving cloudbank.

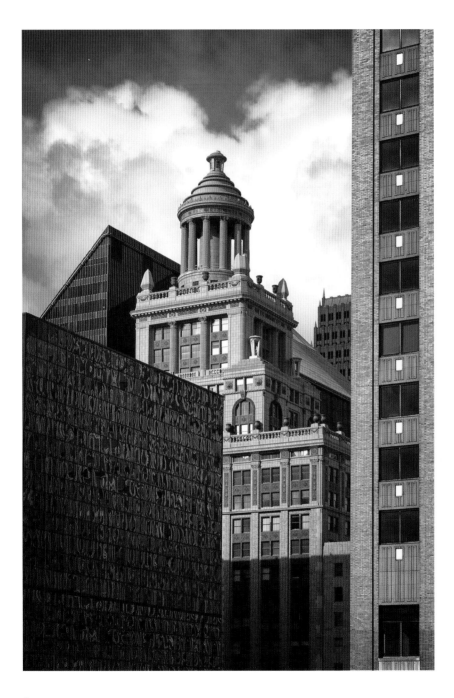

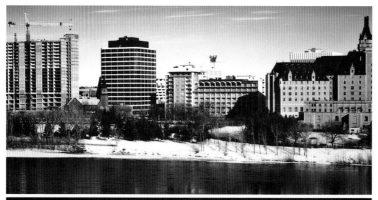

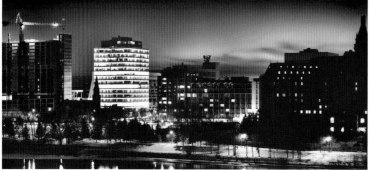

Building managers turn off lights at night to conserve energy. In order to make this office tower stand out, I convinced management to light up the building an hour before sunrise on a winter morning.

This whimsical sculpture in front of an office building situated in the theater district of Houston, Texas, illustrates how an interesting foreground can enhance an otherwise ordinary documentary photo. In addition, note how well the digital capture process records the delicate spectrum of whites and light grays at the upper end of the tonal spectrum.

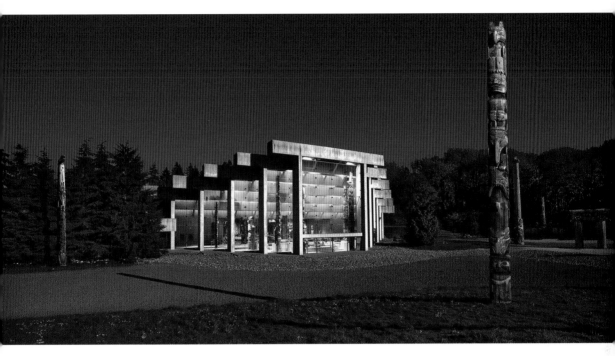

with sleek metallic surfaces or curtainwalls of colored mirror glass, changes in the light conditions will be amplified at certain angles. Polarizing filters are helpful in emphasizing and deemphasizing certain reflective phenomena, although they can make some varieties of glass appear distorted or discolored.

 Light can be used to isolate and emphasize tall buildings even after the sun has set, assuming the cooperation of the building management. Many tenants switch off office lights at the end of the day in order to save energy. If the building you are shooting is completely lit up at 3 AM, there is a good chance that it will stand out boldly against a mainly dark field.

This image of Arthur Erickson's Museum of Anthropology at the University of British Columbia was built from several images shot at different times of the day. The main panorama was created with my 24-mm PC lens shifted left and then right. I marked the spot where my tripod was situated for these shots and returned a few hours later to capture the glowing interior, which was substituted for the darker window view from earlier in the day. The totem poles were photographed on the site, but relocated photographically to strengthen the composition: their shadows were added later, and the overall tonal range was adjusted to simulate evening light.

7 AVAILABLE-LIGHT INTERIOR PHOTOGRAPHY

Ambient or available light is the combined illumination from all sources impinging on a particular scene. Many rooms are partially lit by windows, so the brightness, dynamic range, and even the color of light will vary according to the time of day, the weather conditions, and the seasons. In addition, there is usually light from artificial sources. And each incandescent, fluorescent, or gas-vapor fixture projects a unique pattern of highlight and shadow together with

a unique color spectrum. Designers exploit this variety to create spaces that are functional and attractive.

7–1 AVAILABLE LIGHT AND DIGITAL CAPTURE

Not long ago I used to travel to location assignments packing more lighting than camera equipment. The extra hardware was required to support or replace the available light in a way that better matched the tonal and color characteristics of film. Lots of power was needed to raise the interior illumination closer to the brightness of the landscape visible through the windows and to bring the predominant interior color balance closer to a standard value. Immense effort and expense were associated with acquiring an extensive arsenal of photographic lighting and then dragging it from job to job. Once on location, fine-tuning a complicated set-up could take hours, even with the help of lighting assistants. In addition to all this, the process was intrusive and inconvenient for the occupants of the space, and there was a real risk of damage to the room or its contents. And, of course, it is not easy to deploy photographic lighting in a way that preserves the overall lighting effect the designer had in mind.

To a large extent these problems were due to the characteristics of film, a very excitable medium that responds in a decidedly non-linear fashion to variations in both color temperature and luminosity. Digital sensors, on the other hand, are much calmer; they are capable of recording a wider dynamic range and a wider color spectrum in a more linear fashion than film. Under optimum conditions a well-exposed raw file will hold more color and tonal information about a given scene than any piece of film ever could. Moreover, a healthy raw file can be further improved with the help of Photoshop and Photoshop plug-ins, which can be used to extend dynamic range, neutralize color distortions, and enhance resolution. Tools such as Merge to HDR and iCorrect Edit Lab can modify the whole scene at once, but almost as easily, you can make local color and density corrections anywhere inside the image using a range of selection tools in combination with cut and paste, Levels, Curves, Hue/Saturation, and other commands. With a set of bracketed exposures in hand, even the most complex

photographic problems will diminish significantly after an hour or two of skillful electronic manipulation.

Photographic lighting is used primarily to manage extremes of contrast and color. If both can also be managed during the digital workflow, this begs the question: does digital control trump lighting control? For many practical purposes, it does.

Photographic lighting is an active intervention—a supplement and a support to the available light. Digital control is more passive and remedial. Photographic lighting is used to fix photographic problems on the spot, in real time. Digital controls are used to export photographic problems away from a physical location to a virtual location where corrections can be made at a time and pace of one's own choosing. There are many reasons why this is preferable: The immediate feedback inherent in digital imaging supports quicker, more effective decisions about how to deal with photographic problems. It takes less time to make several bracketed exposures than it does to set up even the simplest photographic lighting. The elimination of complex lighting set-ups eliminates lighting assistants and reduces the bulk and weight of equipment. This reduces insurance costs while making traveling easier and cheaper. It also reduces physical risk to rooms and contents and any inconvenience to the occupants. In addition, the efficiency of digital available-light photography means more images can be made in a shorter time. And creativity is encouraged when experimentation is cost-free.

7–2 A COMMON LIGHTING PROBLEM

Before considering various shooting scenarios, we need to take a look at one specific technical issue common to all available-light work, which I will call the gradient effect. The gradient effect has to do with image areas situated between patches of extreme light and dark. A perfect example is the window mullion, which, together with the window frame, creates a dividing line between bright light coming in from the exterior and the image's darker areas. (Light fixtures and highly reflective surfaces create similar effects.) In a perfect world, these dividing lines would read in a photograph as clean, sharp edges. In the real world we see instead

a gradient, a transitional shift composed of intermediate tonal values between adjacent areas of light and dark. The shorter (or faster) the gradient, the sharper the edge. The longer (or slower) the gradient, the softer the edge. A number of factors conspire to make the gradient effect a worrisome phenomenon in available-light photography: First, there is optical diffraction, the bending and spreading of light waves as they pass by an obstacle. In pictures that include bright windows, the mullions and window frames are just such diffraction-inducing obstacles. Second, there is optical flare caused by scattering, reflection, or diffraction of non-image forming light inside a lens. This happens whenever a bright light source occurs within or just outside the field of view. And finally, there are sensor blow-out and sensor bloom, which happen whenever sensors experience severe illumination overloads. Bloom most frequently shows itself as a colored fringe at or near the highlight/shadow edge, while blowout reads as a blank, fuzzy-edged blur totally devoid of detail.

Diffraction-induced flare manifests as a haze that washes out the image, reduces contrast, and obscures image detail. Sensor bloom and sensor blow-out displace real image information with self-generated artifacts. These aberrations are always present, but in low-contrast situations their effect is subtle, while in high-contrast situations they become more obvious.

Since diffraction and flare are optical issues, they can be minimized to some degree by optical precautions. High-quality lenses handle subjects exhibiting high contrast better, because they are made from special rare-earth glasses, have very effective anti-reflection coatings on the lens elements and on interior walls, and incorporate internal baffles and flocking designed to minimize internal reflections. A lens shade with a shape that is precisely tailored to your lens can further minimize flare.

But good lenses and lens shades will only go so far, and sensor problems cannot be remedied at all by optical means. The only photographically convincing fix is a variation of copy and paste in Photoshop. Select individual mullions and window frames from darker views, and then import these details into lighter exposures. Adjust the density and color of the copied information so

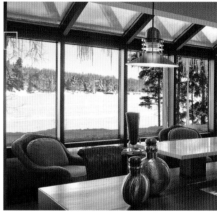

Digital sensors are improving, and with top-of-the-line cameras there are not many image flaws that result directly from sensor shortcomings. The top left and center images are unaltered magnifications from an image of an interior scene that looks out onto a winter landscape. The detail from the darker exposure (left) shows green and cyan fringing at the junctions of dark and light areas, a consequence of the Bayer filtration scheme necessary to achieve full-color reproduction. The detail from the brighter exposure (center) shows fuzzy white blobs, or blooms, that occur whenever sensors are overwhelmed with too much light. The top right image shows the result of carefully combining the bracketed exposures using a variety of Photoshop controls to minimize or eliminate sensor-related defects. This level of effort is not required when full-frame images are reproduced at modest magnifications, but for big enlargements it most certainly is.

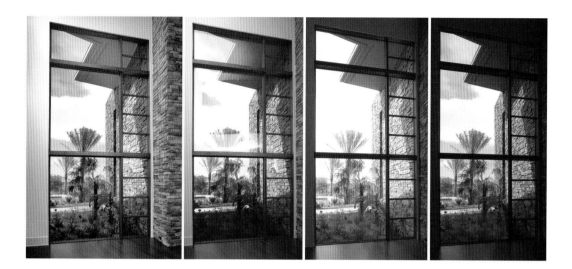

that the grafts blend in. Make your selections with a one- or two-pixel feather, so that the new elements bring sharper edges to the lighter image, along with tonal density and image detail. The process can be time-consuming—some patience is required in making the selections when windows are transected by plants, knick-knacks, or bits of furniture—but it is still easier and faster than setting up supplemental photographic lighting.

7–3 EVALUATING AVAILABLE-LIGHT CONDITIONS

Earlier I suggested that photography begins with an appreciation of the qualities of light: color, intensity, direction, and specularity. This is true for exterior as well as interior photography. A thoughtful evaluation of the ambient light will reveal the photographic potential of a particular room. This can be complicated because rooms are normally lit by multiple sources, each of which generate and/or modify light differently. Color balance and intensity are controllable digitally, but relative color balance and relative intensity are tricky to detect and manage. Multiple artificial light sources are never truly uniform in brightness or color, and these variations can be exaggerated during photography. Moreover, light from multiple sources strikes interior surfaces and objects

Three exposures were combined to make the final image on the far left. First, a flash-lit shot was made to capture the mullion detail. Note the unsightly reflection (second from left) that resulted from having to work in a very narrow entryway. Next, exposures were made to capture detail in the sunlit exterior (far right), and the shadowed exterior (second from right). These window views were then inserted into the flash exposure, and all three were balanced for pleasing color and density. A slight perspective correction brought the whole frame into proper alignment.

from multiple directions, creating sometimes confusing patterns of light and shade. Specularity, the relative size of a light source in relation to the subject it illuminates, is also hard to judge, since multiple sources read differently from different positions within the space.

And what exactly is the subject of an interior photograph? The walls, floor, and ceiling? The objects inside the room? What about the light fixtures and the windows? The answer, of course, is all of the above, which makes the evaluation process even more complicated. Luckily, we have access to some very helpful tools.

7–4 WORKING TETHERED

In the old days photographers depended on expensive and wasteful instant films to provide a preview of how camera, lens, light, and film might render a scene. Today all digital cameras are equipped with full-color LCDs operating in real time and at zero expense. Even better previews are possible with the help of laptop computers, which can interface with prosumer and professional cameras over Firewire, USB, or wireless connections. A laptop can greatly enhance our ability to evaluate digital images on location, as nuances of image tone, color and detail are easy to see on a 17-, 15-, or even 12-inch screen. Some cameras can be controlled from the keyboard, with ISO, aperture, shutter speed, file size, shooting mode, and shutter release adjustable with a simple mouse click. In addition, files generated by a tethered camera can be backed up to the hard-drive on the fly.

Non-professionals are often reluctant to make judgments about a photograph based on what they can see in a dim viewfinder or a small LCD screen. But everyone can relate to bright, clear images on a big color screen. Problems can be identified, fixes suggested, and remedies tested, all within a few minutes.

7–5 INTERIOR DAYLIGHT

Color balance is not an issue when shooting a room by available daylight, but dynamic range usually is. Sensors are designed to work at a color temperature of 5,500°K, so window light will read more or less neutral. Variations in daylight color balance are

Connecting a high-end digital camera to a laptop computer makes location photography an exercise in precision. Here my Canon 1DS MKII is connected by a Firewire cable to my Apple MacBook Pro. Also connected to the computer is a portable 160GB Firewire hard-drive for back-up storage of the raw images. Canon's Digital Photo Professional software provides large image previews (with histograms) on the laptop screen, plus remote control of many camera functions—this is very helpful for all general shooting, and extremely useful when the camera is mounted up high on a ladder. The inset shows the Canon 1DS MKII equipped with a WFT-E1 transmitter that makes a wireless connection between camera and computer.

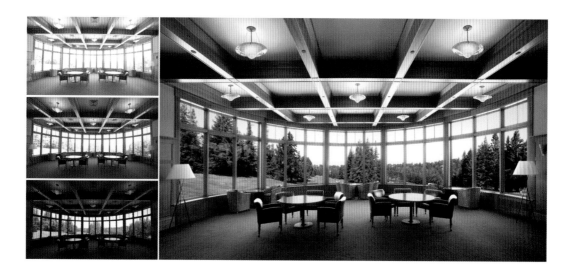

accommodated automatically with the camera's Automatic White Balance (AWB) setting and can be further fine-tuned in Photoshop. But any interior, aside from a greenhouse, a sunroom, or a predominantly glass atrium, will present a contrast problem that likely cannot be dealt with in a single exposure.

The dynamic range created by available daylight is determined by the size and placement of the windows, the nature of the daylight entering the space, and the reflectivity of the walls, ceiling, and floor. If the sun is shining directly through the windows, contrast will be extreme and several widely bracketed exposures will be needed. If the window light is softer as a result of an overcast sky or a northern exposure, the dynamic range inside the room will be considerably narrower. In this case, blending selections from only two or three exposures will be sufficient. The size of the windows also plays a role—the larger the windows, the lower the dynamic range—as does the disposition of blinds, drapes, and translucent sheers. If the major surfaces inside the room are very dark, the dynamic range expands, while light-colored surfaces dramatically shrink the dynamic range, making interior photography easier.

The histograms from a few test exposures will quickly indicate how you should bracket exposures in order to build a

I used three exposures (left) to build the final composite image (right) of this lounge at a California golf club. The final image encompasses not only the whole tonal range presented by the subject, but has also been corrected for barrel distortion and overall rectilinearity. I addressed local anomalies resulting from the use of an extreme wide-angle lens—14-mm in this case—individually: note the shape of the hanging light fixtures in the final image, for example.

composite image that encompasses the entire range of luminosities present in the scene.

7–6 INCANDESCENT LIGHT

The artificial light source for typical domestic interiors and some commercial interiors is often entirely tungsten-incandescent. When shooting these spaces at night, or during the day with window shades drawn, you can easily address color balance with one global correction. One possibility is to use a tungsten-to-daylight color-conversion filter over the taking lens, but many digital cameras also provide for user-selectable color balance. When the camera offers only a general tungsten or incandescent setting, use that. If you can dial in Kelvin color temperature, use 2,800°K for ordinary tungsten bulbs and 3,200°K for tungsten-halogen lamps. Fine-tune the result with iCorrect or during raw-file conversion. For precise color correction, include a gray card in the scene.

Obtaining a pleasing color balance is usually a straightforward exercise, but coping with the variations in direction, intensity, and specularity associated with one or more artificial light sources is not. Even a single incandescent fixture can have a complex photographic signature arising from the way in which the light from a bare bulb (or bulbs) is focused, softened, or redirected by reflectors, baffles, diffusers, shades, and mounting hardware. There are several ways to cope with the arising problems: Relative brightness can be addressed by turning lights on or off before or during exposure, by changing light levels with built-in dimmers where available, or by simply substituting lamps of different wattage. Portable lamps can be repositioned or removed entirely for better photographic effect. Lamps that plug into the wall can be dimmed with in-line controls or turned on or off from the camera position during long exposures with in-line sound-sensitive (clap-on, clap-off) switches, both of which are available from any big hardware store. Harsh shadows and irregular light patterns can be softened with neutral-colored diffusion filter-sheets available from suppliers of professional photographic or cinematographic lighting. In a pinch, a few layers of diffusion material will cut brightness as well, but watch out for overheating.

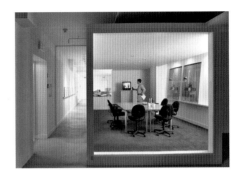

This shot required precise alignment of vertical and horizontal lines. The lighting effect was achieved by manipulating the balance of available light using existing dimmers, switches, and window blinds. No supplemental lighting was required. A bit of energy was introduced by having the executive remain still (foreground) while the receptionist (background) was allowed to work during the two-second exposure.

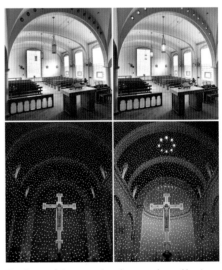

The photos of these two chapels were enhanced by simply switching existing light fixtures off or on. (The white dots in the two bottom photos are 1-inch cubes that were randomly situated on floor-to-ceiling wires according to the architect's specifications. The cube/wire array creates an airy divider with a celestial feel.)

Blown-out photographic detail in and around illuminated light fixtures can be corrected in Photoshop by copying and pasting from appropriately exposed brackets.

7–7 FLUORESCENT LIGHT

Ordinary fluorescent tubes are physically larger and closer to daylight in color temperature than incandescent lamps. They are often used for soft area lighting under cupboards or inside cabinets and display cases. Banks of ganged fluorescent fixtures are typical in commercial interiors. Used this way, they are broad, low-contrast sources. But fluorescents are also found in folded or coiled configurations small enough to be retrofitted into standard incandescent sockets. As such, they are harder, more specular sources similar to the ordinary bulbs they replace.

Typical fluorescent tubes radiate a non-linear color spectrum with a pronounced green spike. As people have become more sensitized to the health benefits of a more natural spectrum, commercial fluorescent lamps have been developed that read more like daylight and domestic fluorescent fittings that read more like incandescents. Naturally, as lamps wear out and are replaced, multiple fixture installations gradually deteriorate into a checkerboard of random color variations. All this would be a spectral nightmare with film, but digital sensors are more forgiving. In most cases AWB will take care of the initial color balance. If an overall green or yellow cast persists, it can be corrected in Photoshop using Image : Adjust : Hue/Saturation to desaturate the offending color channel(s) by small increments until a natural look is restored. Finalize the correction with iCorrect or Image : Adjustments : Color Balance.

A room lit entirely by multiple fluorescent ceiling fixtures can usually be captured in one exposure with the exception of the light fixtures themselves. Blend a second exposure—dialed down to capture very bright highlight detail—into the final image so that the lamps and diffusers do not read as big, blank blotches. This procedure may emphasize the color variations between individual fluorescent tubes, which can be corrected in Photoshop. Make a general selection of all fixtures visible in the frame with the Lasso

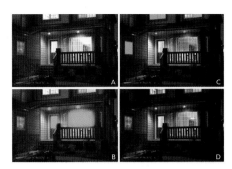

One of the most useful Photoshop operations provides a way to add missing detail to overexposed areas such as light fixtures. The top left is a compromise exposure that includes adequate image information for all but the brightest areas within the image. I selected these areas with the Lasso tool, feathered by 150 pixels (the resulting selection in the bottom left is highlighted in blue). I copied and pasted a darker frame into the selected areas and fine-tuned with Levels to match the surrounding area. In the top right image, I selected bright areas with sharp borders with the Polygonal Lasso tool, feathered by one pixel (highlighted in green). Once again, a darker image provided image information that I pasted into to make the final, wide-tonal scale image (bottom right).

Fixed form-factor lens shades are great tools, but sometimes they are not aggressive enough for maximum flare control. I use a black flag attached to an articulated control arm that mounts on the camera via the hot-shoe for precise protection from extraneous light-sources.

tool (feathered to about 50 pixels) or with the Magic Wand, and then choose Image : Adjustments : Hue/Saturation to desaturate the master channel and bring everything to a more neutral level. If the resulting effect looks flat, subtly reanimate the selection with a touch of global color (use a hue appropriate to the image) with the Levels command.

An entire ceiling filled with lights can result in flare that defeats even the most carefully sculpted lens shade. A broad, black flag positioned carefully above the lens helps attenuate non-image forming light. Flare cannot always be avoided, however. It will be most apparent where several bright fixtures abut darker walls and moldings. Here an intermediate exposure bracket, about a stop and a half below the general room exposure, can be pasted

This quartet of images showing Watten Carther's trio of glass sculptures in the lobby of a new building in Hong Kong traces a successful film-to-digital conversion. I took the original image (upper left) on transparency film. The picture shows the green caste resulting from fluorescent lights in the ceiling. At the site we used a cherry-picker to physically apply magenta filters to the lights. The result is shown in the image on the upper right: not a perfect color correction, but I considered it to be reasonable back then. I revisited the image once I had acquired some digital skills and fine-tuned the color balance and color saturation, as well as sharpness and density (bottom left). Once I completed this work, the image looked somewhat sterile, so I introduced a bit of flare on the ceiling. The final image (bottom right) looks more natural.

in to replace washed-out detail and degraded edges. Sometimes relatively large image areas are subtly, but noticeably softened by non-image-forming light. Select the affected region with a well-feathered lasso and subtly bump the contrast and color saturation with the appropriate controls.

7–8 SODIUM AND MERCURY-VAPOR LIGHTING

Sodium and mercury lamps differ in color: electrically energized sodium glows yellow, not unlike incandescent lights, while mercury glows on the blue side of daylight. Both can be roughly accommodated by AWB in the camera and then fine-tuned during raw conversion or in Photoshop. Since both types of lamps are non-linear sources, you will need to enrich or attenuate individual hues with the Hue/Saturation controls to achieve a natural look.

Specularity, not color, is the bigger issue here. A ceiling fitted with banks of fluorescent fixtures is photographically similar to an overcast sky, while a ceiling fitted with sodium or mercury-vapor fixtures can be compared to a sky populated by multiple suns arranged geometrically on a rectilinear grid. The multiple shadows that these "suns" cast appear unnatural to us. Disconcerting multiple shadows can sometimes be blended together for a less distracting result. The intersection of two shadows creates an area that is darker than a single shadow. If you selectively lighten this area, the two shadows will merge into one.

At other times the photographic remedy may be as simple as shooting from a low vantage point, thereby eliminating the floor and the many shadows that reside there. But this only emphasizes another issue, particularly if you are using a wide-angle lens: Metal vapor-discharge lamps are extremely bright objects and therefore serious sources of flare, bloom, blow-out, color fringing, and color halos. Sometimes such artifacts can be dramatically suggestive of industrial power, but more often they are just ugly. In the film era, gas-discharge lamps often required multiple color-correction filters that exaggerated the fringing and flare. In the digital era, Photoshop once again comes to the rescue.

The deleterious effects associated with the use of multiple filters can be eliminated altogether by electronically managing

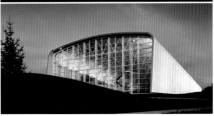

Mercury-vapor lamps rendered the interior of a building housing a swimming pool in London, Ontario as blue-green in color (bottom). I selected the entire window wall with the Polygonal Lasso, feathered by two pixels, and then used Hue/Saturation to bring the color back to neutral by desaturating the cyan channel (top).

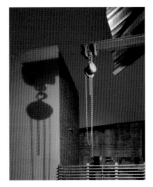

I was commissioned to photograph the results of a renovation that turned a former welding shop into an upscale residence. This image includes a well-situated shadow cast by a sodium-vapor streetlamp. Sodium-vapor light is interpreted by most digital sensors as very similar to the light from tungsten-halogen fixtures and requires only subtle adjustment in Photoshop to achieve a natural look.

color balance. Since flare, bloom, and blow-out are largely the result of overexposure, we again look to merging multiple exposures, but this time exposures that are several stops apart. Make tests at different settings, bracketing widely, and evaluate the histograms. The exposure that preserves image detail inside and at the edges of mercury or sodium-vapor fixtures might be six or seven stops under the best exposure for the general view. Once the brackets are open in Photoshop, initiate Merge to HDR. If this makes the light fixtures look right, you are done. Likely, some additional work will be required. Start with a base exposure that works for everything except the light fixtures themselves. Use the Magic Wand—set to a tolerance of 30/contiguous—to select the overexposed lamps. Feather the selections by about 25 pixels and paste in data from a darker image, adjusting color and density to appropriate values. Use the Eraser tool (set to 50 percent opacity) around the fixtures to firm up edges and bring in detail from the ceiling behind. Finally, flatten the image for output.

7–9 MIXED LIGHT SOURCES

Even though it is much easier to create satisfactory images of interiors under mixed lighting with digital equipment than with film, there are still some problems that must be intelligently addressed.

Despite their difference in color temperature, daylight and incandescent light go together well. When daylight is the predominant source, soft pools of warm light around the lamps and other incandescent fixtures read as welcoming elements once their red/yellow bias has been toned down a notch in Photoshop. (Select with the Lasso tool (feathered by 50 or 75 pixels) and set the appropriate sliders in the Hue/Saturation dialogue box.)

The ratio of incandescent to daylight necessarily changes with weather and time of day. When the incandescent light predominates, adjust the global color balance towards blue in Photoshop. This will make the window views very blue or even blue/magenta. If the scene outside the window is dark enough, the viewer will automatically associate the color with sunrise, sunset, or twilight. A window that looks too blue or too magenta can spoil the illusion. Select it with an appropriately feathered

lasso and desaturate these colors in Hue/Saturation to restore believability.

Stronger interventions are necessary whenever fluorescent or gas-discharge lights appear in the mix. These fixtures have non-linear spectrums that do not naturally harmonize with more linear sources such as daylight and tungsten-incandescent; consequently, the areas they directly affect will have to be treated separately with local color correction and color saturation tools.

Before attempting to micromanage local color disturbances with a bevy of individually targeted maneuvers, try iCorrect in semi-automatic mode. Click the white-balance-tool on one or two patches of neutral tone in each area influenced by a different color temperature light source. Once the preview looks right, select Edit Image. Whatever iCorrect suggests can be attenuated to taste by selecting Fade iCorrect from the Edit menu. Photoshop's Auto-Color or Auto-Levels controls, which can be found under Image : Adjustments in the toolbar, are worth trying as well. Often these simple maneuvers result in an acceptable outcome.

Quite often color imbalance associated with mixed light sources are simple to remedy with Photoshop. In the left image we see a green color caste caused by the fluorescent back-lights inside this sign. On the left the color has been corrected by selecting the offending area and then modifying the color using a combination of Levels and Hue/Saturation controls.

This series of images was adjusted using only global color corrections with the Saturation control in Photoshop. The bottom image was made on film with some magenta filtration to counter the green of the interior fluorescent lighting. The image was scanned and then the yellow and green color channels were partially desaturated in Photoshop, giving a more neutral color balance to the windows. In the middle image, the cyan channel was desaturated a bit to make the atrium, which was lit by mercury-vapor lamps, less blue/green. In the frame second from the top the magenta channel was dialed down to make the exterior and foreground more neutral. After all this, I decided that the photo was looking too dull, and so I consciously restored some—but not all—of the color previously removed. The sky was separately selected and made more blue and the foreground and the upper portion of the sky were darkened a few degrees. The final image is strong enough, but not, by any standard, neutral in color.

8 PHOTOGRAPHIC LIGHTING FOR INTERIORS

As we have seen, much can be done to maximize the utility of available light. Nevertheless, under certain circumstances supplemental photographic lighting can be useful. Color, dynamic range, and intensity can be described quantitatively and are therefore relatively easy to modify electronically, but it is impossible to alter the direction or specularity of a light source after exposure. Whenever the available light is coming from the wrong direction,

whenever it generates unsightly shadows, or whenever it is just plain boring, supplementary lighting will improve the shot.

Of course, the decision to deploy lighting reintroduces problems of cost, time, labor, shipping, and safety. Happily, some of the advantages of digital imaging carry over into the realm of controlled lighting.

8–1 PHOTOGRAPHIC LIGHTING EQUIPMENT

There are four kinds of photographically useful artificial light: tungsten light (also called incandescent or hot-light), gas-discharge light, fluorescent light, and electronic flash. Tungsten lights, gas-discharge lamps, and electronic flash tubes are small compared to the objects they illuminate; when they are used without a modifier such as a reflector or a diffuser they are sources of hard light. Tungsten, gas-discharge, and fluorescent light is continuous, whereas electronic flash generates light in short pulses. Electronic flash is extremely efficient—the pulse, though short, is very bright. The brevity of the flash is a blessing in disguise. Its duration is so short that both subject motion and camera shake are eliminated. Since the flash is very brief, it can be synchronized to fast shutter speeds—up to 1/250 second for modern focal plane shutters—allowing precise control of the balance between ambient and flash lighting. Digital sensors respond very well to electronic flash, exhibiting none of the reciprocity effects related to short exposures that occur on film. In order to preview the effects of the flash and to provide sufficient illumination for focusing, a small tungsten lamp, called a modeling light, is mounted near the flash tube in professional studio flash units.

Due to the elaborate electronics involved, professional electronic flash equipment is expensive and heavy compared to tungsten lamps, which are simple in construction and relatively lightweight. Tungsten lamps are not very energy-efficient, however. A lamp rated at 1,000 watts will use 200 watts of electricity to produce light and 800 watts to make heat. Because of this characteristic, hot-lights can damage heat-sensitive materials or even start a fire. An ordinary tungsten glass lamp darkens and changes color with age, while quartz-halogen tungsten lamps are

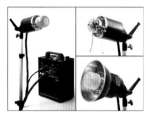

On the left, a professional 2400-ws electronic flash head mounted on a light-stand plus the powerpack with controls for adjusting output brightness. On the lower right is the flash head fitted with a small reflector, one of literally dozens of available attachments that change the distribution pattern, color, brightness, and specularity of the light. The image on the upper right shows the arrangement of the flash tube (blue-tinged for clarity) and the tungsten model lamp (yellow-tinged) visible with the protective diffusing dome removed.

more consistent in terms of both color balance and brightness. Both types of lamps are delicate and will fail if they are jarred while operating. Life expectancy ranges from fifty to two hundred hours. Despite these inconveniences hot-lights are very useful for interior photography; their bright, continuous illumination makes focusing and framing easier and lighting effects may be easily seen and therefore finely controlled. Some people also feel that the warmer incandescent spectrum renders a more natural look than the cool light from electronic flash.

Photographic lighting is an art, but lessons in lighting for aspiring architectural photographers are easily available at any newsstand. High-end design magazines feature many beautifully lit images; I encourage you to deconstruct them in order to discern the position of major ambient light sources such as windows and integral light fixtures, as well as photographic reflectors and lighting instruments. Study the intensity and the orientation of highlights and shadows, as well as the nature of the tonal gradients that separate them. Build on this information to imagine the relative size and placement of the lights and reflectors that created the look. Your own emotional responses will teach you how lighting works to evoke a range of moods.

8–2 ELECTRONIC FLASH

I use unfiltered electronic flash to complement or overpower available daylight, and electronic flash filtered with green gels (available from photographic and theatrical lighting suppliers) to complement or overpower fluorescent or mercury-vapor ambient sources. Because the technology for generating electronic flash light is so complicated, the flash head is less flexible than its incandescent counterpart. Nevertheless, several well-developed professional flash systems such as Profoto (http://www.profoto.com/), Speedotron (http://speedotron.com/), and Norman (http://www.photo-control.com/) offer a wide selection of reflectors, honeycomb grids, snoots, umbrellas, and softboxes to fine-tune the output of their flash heads. Flash heads bounced from umbrellas or through softboxes will simulate the effect of indirect daylight transmitted through large windows, while grids,

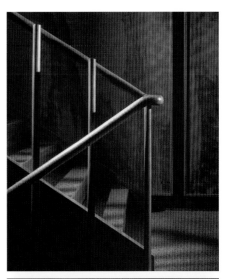

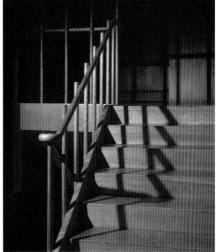

Sometimes it is necessary to take control of the lighting in order to do justice to the subject. For the top image I used two fairly hard light sources to provide strong modeling on the cylindrical banister. For the bottom image just one light was sufficient to make a dramatic shot in which shadows became a compositional element. Working tethered to a computer makes lighting set-up and fine-tuning easier.

snoots, and parabolic reflectors create effects that mimic more direct sunlight.

Flash power is measured in watt-seconds (ws). A small, camera-mounted unit generates around 50 ws, while a large professional flash lies in the range of 4,800 ws. A typical heavy-duty power pack produces 2,400 ws. Many assignments can be handled with one large power pack and three or four flash heads.

After each flash discharge the unit needs to recharge, a process referred to as "recycling." Recycle times can range from less than one to thirty or more seconds. Big units draw heavy currents—up to twenty amperes—when recycling fast. Professional powerpacks have a switch or dial that permits slower recycling for locations where the electrical supply is limited. I strongly recommend using infrared or radio triggers in place of endlessly troublesome synch cords.

Professional flash equipment is very useful but also very expensive to buy. However, any big city will have several rental houses that service professional photographers. They are usually very cooperative about shipping rental equipment anywhere in the country at reasonable rates.

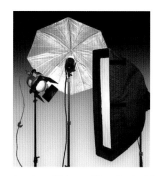

A variety of light modifiers: On the left, a spotlight with barndoors, used for illuminating small areas with precisely controllable shafts of light. Photographic spotlights are available in a range of sizes, from less than 4 to more than 18 inches wide. (The smaller units are the most useful for architectural work.) In the center, a photographic umbrella, used for generating broad, soft washes of light. Umbrellas are available with white, silver, and gold reflective surfaces, and in a range of sizes from 18 inches to several feet. Forty- to sixty-inch umbrellas are useful for lighting up entire rooms. On the right, a softbox. These handy collapsible units come in a variety of sizes. They provide a way of controlling the spread and directionality of soft light that is not possible with umbrellas.

8–3 TUNGSTEN LIGHTING

I rely on tungsten lights when interiors are predominantly lit by incandescent or sodium-discharge lamps. Companies such as Lowel (http://lowel.com), Smith-Victor (http://www.smithvictor.com), and Calumet (http://www.calumetphoto.com) offer durable as well as lightweight and compact systems. I own Lowel equipment because I find it an extremely flexible system. A Lowel DP light can handle up to 1,000 watts and its beam can be varied from 15° to 90°; the range of the beam can often be further extended with snap-in reflectors. When buying a lighting system, make sure multi-leaf barndoors and a variety of different-size flags can be easily attached. A solid umbrella clamp and a large, comfortably cool handle are also important as are a variety of fasteners, adapters, and stands to facilitate mounting lights and accessories in all kinds of situations.

A professional tungsten system can be used in many different ways but my favorite approach is to bounce the lights off

PHOTOGRAPHIC LIGHTING FOR INTERIORS

8–3 TUNGSTEN LIGHTING
8–4 A MODEST SYSTEM
 SAFETY

strategically positioned light-colored walls or reflector cards of various sizes, using the focusing capability of the lamps to tailor the pattern and intensity of the light. I use grids and snoots to generate sharply focused beams when I want to highlight small areas.

8–4 A MODEST SYSTEM

Since digital equipment can handle a wide range of available-light situations, I now travel with only a very modest lighting kit. My mini-system is built around a compact, lightweight 2,400 ws electronic flash pack. I carry two flash heads with focusable 7-inch parabolic reflectors, two light stands, a 42-inch umbrella, and a medium (14 by 56 inches) collapsible strip softlight. These items, together with cables, radio triggers, black masking tape, and a fabric reflector, fit into a small rolling case that weighs just under 50 lbs, the cut-off point for checked luggage on most airlines.

Electronic flash is very efficient, and 2,400 ws is a significant amount of light. With the pack set to full power and the camera set to ISO 800 I can light up most domestic spaces and substantial areas of many commercial interiors. For subtler work, the power can be dialed down by several stops. I carry daylight-to-tungsten and daylight-to-fluorescent filters so that I can match the supplemental lighting to the predominant color balance of the interior in question. I secure my fabric reflector, which is shiny silver on one side and black on the other, to walls, light stands, or furniture with masking tape or thumbtacks and use it to bounce light into dark corners, block flare-inducing windows, or wrap shiny objects to minimize reflections.

SAFETY

Professional electronic flash equipment operates at high voltages and can be extremely dangerous. Training is required to ensure safe operation. Read the manufacturer's instruction manual and obey the recommended safety precautions. Check connectors and cables often and immediately stop using any that look worn. Make certain that light-stands heads are secured with weights and that wires are safely taped to the floor when working on location.

On the right, a photograph depicting Warren Carthur's glass sculpture entitled *A Prairie Boy's Dream*, situated in the lobby of the Investor's Building in downtown Winnipeg. This image was shot on film and required several powerful lighting stacks, one of which is pictured on the left, to give the heavy glass panels a luminous appearance. (If I were shooting this project today, the luminosity of the glasswork would be established and enhanced with software, not hardware.)

Never allow flash equipment to be operated by people unfamiliar with it. Do not use flash equipment in a wet environment or in the presence of flammable vapors. Extension cords for use with flash generators should be made of sixteen-gauge wire, or fourteen-gauge for runs longer than fifty feet. Make certain that flash units are supplied by grounded receptacles of adequate size. Always switch powerpacks off before connecting or disconnecting flash heads and always leave flash units unplugged and discharged when unattended.

Quartz-halogen lights operate at very high temperatures. Do not handle lamps with bare fingers during installation—skin oils can cause uneven heating and may result in fractures or even explosion. Use gloves when adjusting. Watch out for the possibility of heat damage or fire and make sure that everyone involved in a shoot is well aware of the burn risk.

8–5 PAINTING WITH LIGHT

Lighting a large space generally requires heavy-duty equipment and might seem beyond the capability of amateurs. But there is a low-budget technique called painting with light that can mimic the effect of several thousand dollars worth of hardware. It requires only one photographic fixture. To take a picture, mount the camera on a tripod and select a low ISO setting and a small aperture. Switch off the room lights and lock open the camera's shutter. When exposure begins, stand beside the camera while slowly sweeping the scene with the beam of a photo-lamp. Each pass should be smooth and steady. Darker areas can be hit two or three times. If you wear dark clothes and the ambient illumination is low, you can apply light while actually walking around inside the scene, remembering of course, to never point the hand-held fixture at the camera. The final image will be a seamless composite that has been painted into existence, stroke by stroke. You can use the same approach with a portable electronic flash, using multiple discharges to expose large areas incrementally. A starting exposure can be determined with a flashmeter and a single pop of the flash, then fine-tuned according to the appearance of the image on the camera's LCD and the histogram.

This elevation of the IKOY Architects office in Winnipeg was shot with the painting-with-light technique. During a two-minute exposure I walked through the shot carrying a 1,000-watt tungsten flood light. You can see the results in the cars, the green support for the stairs, the silver mullions, and the red doors. The parking lot was wetted down with a hose for good measure.

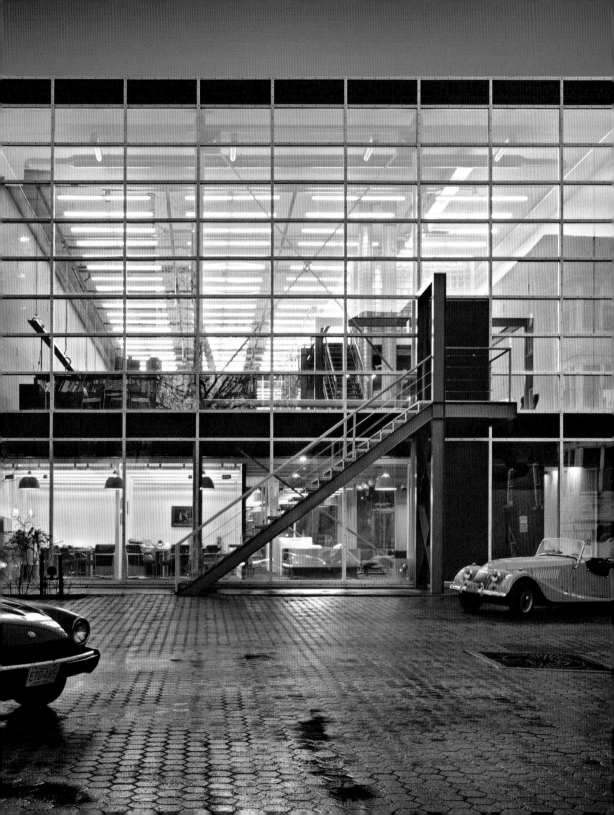

9 SPECIFIC APPLICATIONS

There are a number of specific applications in architectural photography, including shooting details, renderings, and models as well as documentary photography on construction sites. Each has its own difficulties and technical requirements.

9–1 ARCHITECTURAL DETAILS

Photographing details is an important part of architectural photography. Not only can attractive elements be singled out for dramatic effect and to highlight a building's detailing, but they are also sought after by both consumer magazines and professional journals as necessary components in attractive layouts. Small-scale documentation usually requires longer focal-length lenses since it involves the visual amplification of important fragments within a larger structure. It makes sense for an architectural photographer to own a telephoto zoom in the range of 70–200 mm or longer. Tele lenses magnify camera motion and focus errors along with image size, so use a tripod and a cable release. Lenses with built-in image stabilization are great for hand-held work. While shooting with a tele lens is convenient, you can also take dramatic shots of details with wide-angle lenses; the juxtaposition of ordinarily small features with the ordinarily very large can be visually effective.

Even modest architectural elements can be portrayed attractively in detail shots if lit nicely and framed appropriately with telephoto lenses.

Light fixtures, doors and doorframes, windows and window frames, roof and siding materials, and other structural components have a dual function that embraces both practicality and visual appeal. Practical attributes are best shown contextually within larger views, but aspects of visual appeal are emphasized in well-lit and well-composed small-scale "still-life" imagery. Lighting is a matter of taste, although the nature of the specific subject will suggest the most effective approach. Chrome, glass, and polished stone look best when illuminated by soft, indirect lighting from broad windows, an overcast sky, or light bounced off from nearby walls or other large reflectors, while stone, wood, and most fabrics look best under harder, more angular light from direct sun or undiffused photographic lamps.

9–2 PHOTOGRAPHING DRAWINGS, RENDERINGS, AND PERSPECTIVES

The reproduction of existing two-dimensional materials such as drawings or renderings by photographic means is called *copywork*. The basic technical requirements are sharpness, color fidelity, and contrast control. These days a flatbed scanner can do a

Small-scale subjects are relatively easy to manage: in these shots, a single photographic light, tastefully positioned, does the job. A barndoor was used to shape the beam for dramatic effect—this is more obvious in the photo on the left. On the right, the light-pipe behavior of the glass distributes the light to the etched figures. Note also that depth of field is a function of magnification, which can be used to good effect with very small subjects.

fantastic job of digitally reproducing originals smaller than 8.5 by 14 inches. Larger items can be scanned in sections and stitched together electronically, but it is usually more convenient to photograph them.

For all copywork the camera is placed perpendicular to the material being copied. Lights should be positioned at 45° angles on either side of the camera in order to project an even field of illumination. A single light source is perfectly acceptable as long as it provides uniform brightness over the whole image area. A sweep of sunlight uninterrupted by shadows will work, as will available daylight from a big, north-facing window. You can also use electronic flash. Connect an ordinarily camera-mounted flash off-camera with a dedicated extension cable or mount one or two professional flash units on light stands. I prefer tungsten light for copywork because a bright, continuous light source speeds up camera alignment and focusing. A little care must be taken with

This portfolio of ornate architectural details was made during an evening stroll around some of Winnipeg's heritage buildings. The photos were shot hand-held with a 300-mm telephoto lens. No perspective control was used.

heat-sensitive originals, but normally there is no problem if exposures are kept short.

When the material to be photographed is not perfectly flat, changing the angle of the light will sometimes eliminate unwanted reflections, shadows, and hot-spots, but some shiny, irregular surfaces (an oil-painting, for example) cannot be accommodated in this way. Difficult cases require polarization.

POLARIZING FILTERS

Imagine light to be a beam of energized particles—photons—that vibrate as they travel along an otherwise straight path. The frequency of the vibrations determines the color of the light. The plane of the vibrations relative to the direction of travel determines the polarity of the light. For most light the polarization is random and the photons are free to vibrate in any and all directions. A polarizing filter is like a minature picket fence, made up of parallel rows of microscopic crystals in glass or plastic. Light vibrating in line with the orientation of the crystalline pickets can pass through, but light vibrating perpendicular to those pickets is blocked. The orientation of the pickets is the axis of polarization. (Two polarizing filters placed so that their respective axes of polarization are oriented at a 90° angle to one another will be opaque to all light. This property can be invoked electrically in certain materials: LCDs operate on this principle.)

Many materials reflect or absorb light of only one polarity, so the reflectivity of these materials can be altered by changing the polarity of the illumination. Polarizing filter sheets for lights and polarizing filters for lenses are available at professional photo stores. You can remove many troublesome reflections by polarizing both the camera and the copy-lights. Attenuating these reflections improves color saturation, image contrast, and overall sharpness.

LENSES FOR COPYWORK

Ordinary lenses are optimized for infinity focus and three-dimensional subjects that exceed the image size by a factor of ten to one or more. While good-quality normal lenses can be used for

This simple graphic illustrates how a polarizer filter works. Non-polarized light vibrates in many directions as it travels along a path. A polarizer filter is made up of billions of tiny crystals that are organized to form "slots" that block all axial vibrations except for one, called the "axis of polarization." All light, except light that is vibrating along the axis of polarization, is blocked by the polarizer filter. Moisture in the sky and many surfaces, such as glass, some paints, foliage, and water exhibit polarizing effects.

This graphic depicts a typical table-top copystand composed of a baseboard, photographic lights, and a sturdy vertical post with an adjustable camera mount.

SPECIFIC APPLICATIONS

9–2 PHOTOGRAPHICS DRAWINGS, DETAILS,
AND PERSPECTIVES
POLARIZING FILTERS
LENSES FOR COPYWORK
COLOR BALANCE AND FIDELITY

copywork of larger material, macro lenses are recommended when copying smaller artwork. Macro lenses are available in different focal lengths—60 mm, 90 mm, 105 mm, and 200 mm. The greater working distances afforded by the longer macros make copywork mechanically easier. Both regular and macro lenses perform best when their aperture is set two stops smaller than maximum. This reduces the aberrations that exist at maximum aperture, while avoiding the image degradation that occurs as a result of diffraction at small apertures.

To photograph large originals, tape the material to be copied to a wall and position the camera with a tripod. The best tool for shooting lots of smaller originals is a copystand, which, in its simplest form, consists of a baseboard attached to a vertical column with an adjustable mounting-plate for securing the camera. Often it also includes arms for lights that can be adjusted to the desired angle.

COLOR BALANCE AND FIDELITY

Color fidelity is not the same as color balance. In photography the term neutral color balance describes a scene or image that has no overall color bias; when grays are gray, and skies are blue, and grass is green, and skin looks normal, the color balance is neutral. (An 18 percent gray card helps establish neutral color balance when used as a calibration target to determine white balance with a digital camera.)

Color fidelity has to do with accuracy; true color fidelity is achieved only when all colors are reproduced exactly as they appear in reality. Unfortunately, this can never happen. The colors we see on screen are generated by phosphorescent chemicals, and the colors we see in prints are generated by chemical dyes, all of which are physically limited in their ability to imitate the real world.

The spectral response of photographic systems can be expressed in numbers with graphs of spectral sensitivities, but the bottom line is that photographic reproduction is not honest about some colors. This is bothersome for precision copywork, particularly of architectural renderings, where color fidelity is important.

Anyone who expects copy prints that closely match the originals should study the limitations of the medium. Comprehensive testing is the only way to achieve predictable results. Once you know how certain colors reproduce, you can select colors for renderings and perspectives intended to be copied according to how well they photograph.

9–3 ARCHITECTURAL MODELS
TECHNIQUE

When photographing architectural models three factors are important to take into account: scale, point of view, and the degree to which real-life conditions are simulated. The complexity of the model governs the complexity of the photography. As a rule architectural models should be lit in a way that mimics sunlight; this is easy to do with a single tungsten light and several large white reflector cards positioned to brighten up the shadows. The general direction of the "sunshine" can be determined from the site-plan specifications or simply by choosing an angle that looks best. Glass, metal, or plastic surfaces may be embellished or highlighted by carefully placing an additional light or a card of an appropriate color or texture so that its reflection is visible from the camera position. An alternate approach is to electronically apply blurred images of city skylines to the windows of models to simulate realistic reflections.

Several different vantage points or points of view may be required. The street level view is the trickiest to carry off convincingly. The center of the lens will be only a fraction of an inch off the artificial "ground" in order to duplicate an eye-level perspective. Elements of the fabricated landscape, such as miniature trees, vehicles, and other buildings, can be more difficult to deal with than their real-life equivalents. Nevertheless, the same camera movements are required to maintain the parallelism of vertical and horizontal lines, so PC lenses come in handy. Most DSLR manufacturers offer a right-angle-finder that permits easier access to the viewfinder during the positional contortions that are often necessary when shooting architectural models.

These images show two structures of monumental proportions, but this is immediately visually apparent in only one of the photographs. On the top, a human figure within the frame quickly informs us about the size of the sculpture. On the bottom, only a hard-to-find light bulb provides us with evidence of how big the Buddha really is. In the absence of solid clues about scale, buildings in architectural photos can be easily read as models, leaving the viewer confused.

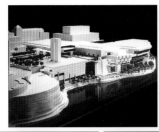
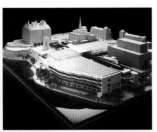
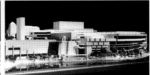

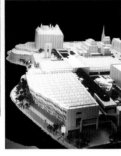

Since depth of field is inversely related to magnification, maintaining focus becomes a problem with small subjects. This was a critical issue when this work had to be done with view cameras, but the DSLR makes close-up photography much more manageable. (The tilt capability built into the Canon PC lenses is very useful here.) Even so, small apertures are required to hold the focus from front to back.

BACKGROUNDS

Since models usually consist of simple geometric forms, it is relatively easy to insert a sunset or sunrise in Photoshop. Create a mask around the miniature skyline using the Polygonal Lasso tool, feather by one or two pixels, and then copy and paste an appropriate sky from another photo. The photographic texture of the two components can be matched by adding some digital grain (Filter : Noise : Add Noise) and then softening with Gaussian Blur. Lighten or darken for the most realistic appearance with the Levels tool.

A low-tech artificial sky will also work: tape a length of blue seamless paper (available from photographic suppliers)

The key to successful photography of architectural models is to treat them just as if they were real buildings. This means the careful selection of strong points of view, perspective control, and appropriate lighting. Some models, such as this mock-up of a proposed National Gallery for Canada by architect Clifford Wiens, are more or less monochromatic and can be rendered quite well in black and white.

to the wall behind the model. Paper slightly darker than the real sky works well if it is lit from the bottom to give a graduated effect. This simple method provides good results if implemented tastefully and has the counter-intuitive advantage of not looking too real.

In order to shoot several views from different angles rotate the model itself, rather than reposition the camera if working with a paper sky. When moving the model take care to move the artificial sun as well, to ensure that sun angles will remain consistent from image to image. Of course, you can also shoot the model outdoors, provided a location is available that affords an unobstructed view of the real sky.

9–4 NIGHTTIME PHOTOGRAPHY

Shooting at night can be a good alternative to daylight photography when you are looking to avoid bad sun angles, eliminate intrusive urban clutter, or to show off a building in a novel way. Of course, nighttime photography comes with its own set of problems, including low light levels, high contrast, long exposures, and mixed light sources. Working with film at night used to be a photographic nightmare. Digital cameras, with their illuminated LCD screens that allow you to see what you are getting in the dark, make this work much easier to handle.

When planning a shoot at night, select camera locations and arrange for access well ahead of time. Talk to building management and maintenance staff to ensure that necessary interior and exterior lighting is switched on. Confirm arrangements with a phone call just before the end of the business day so that chances for confusion in the evening or early morning are minimized. Carry identification and the business card of whoever gave permission for your shoot. High-security locations require a formal letter and/or a security person as an escort. Be prepared to explain what you are doing to the police, as well. And remember, working in the dark is a lot easier when you carry a flashlight.

Interior photography normally involves exposures of less than two minutes, even with low ISO settings. Outdoors at night exposures will be about the same provided you increase the ISO to

800. High ISO settings yield noisier results, but happily, this noise can be attenuated with software such as Noise Ninja (http://www.picturecode.com/). A lower ISO will yield cleaner images, but exposure times might be three minutes or more. With film, reciprocity failure is a big issue: as exposures get longer film quickly becomes unpredictable. Digital sensors, however, are quite linear in their response to long exposures. An approximate exposure can be determined quickly with the aid of the LCD display and the histogram. Autobracketing and Photoshop take care of everything else. Of course, making bracketed exposures of dim nighttime scenes takes time, as does electronically combining them into a single wide-tonal-range image. But the results are superior to anything film can do, so patience is well rewarded.

You can reinforce important details and open up dark areas with some cleverly applied artificial light. If a source of electricity is available, highlight specific areas using the painting-with-light method introduced earlier (see page 108) with a hand-held photographic light of 500 or 1000 watts. Portable battery-operated video lights or multiple flashes from battery-operated electronic flash units will work in locations without access to electricity. Watch out for direct reflections from windows or other

Digital cameras, with their illuminated LCD screens, extended-range electronic shutters, automatic exposure bracketing, and linear sensors make night photography an enjoyable undertaking, compared to the frustrating chore it used to be back in the days of film.

shiny surfaces. If the exposure times are sufficiently long—about three minutes or more—it is possible to lock the camera shutter open and walk up to the target building with the light in hand. If you wear dark clothing and keep moving, you can paint a very large area with light without registering in the photograph.

9–5 PROGRESS AND CONSTRUCTION PHOTOS

Progress photos are needed by architects, engineers, contractors, developers, building owners, or even the bank financing the construction. On very large projects funds may be advanced to contractors and suppliers in stages based on the periodic presentation of photographic proof of work completed. The degree of detail to be recorded depends on the final use of the photos. For example, a construction company may want to show the installation of major structural elements of a steel-and-glass skyscraper, which is easily photographed from a distance. In another situation an architect might be involved in a lawsuit with a contractor over improperly installed fixtures, in which case close-up photos showing the exact condition of the defects are necessary.

DIGITAL INTEGRITY

The main requirement for documentary photography is accuracy, which is problematic with digital images that can be endlessly manipulated. The mutability of digital imagery is a bonus for photographers but it is a serious issue for insurance companies, the courts, and banks. Canon sells a data verification kit (DVK) designed to work with the Canon EOS 1D Mark II, EOS 20D, and EOS 1DS MKII DSLR cameras, which provides the facility to prove that images have not been altered, tampered with, or manipulated in any way.

The Canon DVK package costs about $1,000 and consists of a dedicated card reader/writer, a dedicated memory card, and verification software that automatically attaches a unique digital code to each image based on its contents. When the image is viewed, the verification software determines the code for the image and compares it with the attached code. If the image contents have been manipulated in any way, the codes will not match. Canon claims that a variation of only one bit of image data can be

This progress photo was shot with a hand-held 35-mm film camera and then digitized with a Minolta Dimage Pro scanner and enhanced in Photoshop. The ornate 100-year-old facades of four otherwise dilapidated buildings were shored up with steel buttresses while the original structures were removed and a new building constructed exactly where the old buildings stood.

Delicate digital hardware needs to be protected from contamination by construction detritus.

reliably detected. Nikon offers similar software for use with some of its high-end DSLR cameras.

TECHNIQUE

Color is not always required in progress photos but all images must exhibit high resolution so equipment choices will be similar to other, more exalted kinds of architectural work. Prints must be dated, and all image disks must be labeled and filed for easy access. If you are shooting a series of images in order to show the progress of construction over time, return to the exact same camera positions at approximately the same time of day. This will ensure that the photos make immediate visual sense when viewed together.

Photographs of mechanical details in dark locations require some supplementary lighting. You can light small areas with a camera-mounted flash, but you will achieve better-looking results by connecting the flash to the camera with a dedicated extension cable. When the flash and camera are separated, the subject will be better defined by the texture of shadows and highlights. A professional battery-powered portable flash in the 1,200-ws range can be rented from photo suppliers. If large areas have to be covered, put the camera on a tripod and use the multiple-flash/painting-with-light technique described earlier.

Although most progress and documentary photographs will never be coveted for their aesthetic qualities, it is never a waste of time to try for harmony and balance in any photographs you make. Well-composed images are more appealing and more effective, if only on a subconscious level. Similarly, if you preserve parallel verticals, your work will have a more professional look.

DIRTY OR HAZARDOUS LOCATIONS

Exposure to dust and grime are hard on photographic equipment; cement dust is particularly insidious. It is prudent to protect your camera and lenses from harmful exposure to the detritus of building sites by observing a few simple precautions: first and foremost, digital sensors are difficult to clean, so avoid changing lenses at dirty locations. A decent zoom lens around the 24–105-mm range will cover 90 percent of this work, making lens changing largely

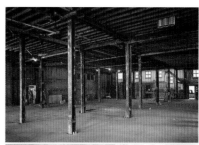

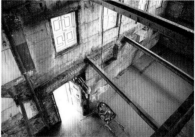

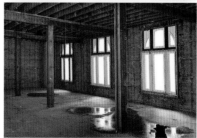

Progress photos can be fun. These four shots are samples from a continuing documentation I made of the gutting and renovation of a heritage building. All were shot hand-held by available light with a Canon 5D full-frame DSLR and a 24–105-mm zoom lens with image stabilizer. These pictures were all made at ISO 1600 to allow for reasonably fast shutter speeds in rather dark environments.

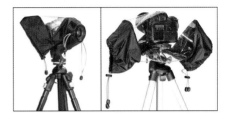

unnecessary. When you do have to switch optics, do it somewhere calm, such as inside a vehicle.

Avoid windy and rainy days. When dusty or wet conditions are unavoidable, put your camera in a plastic bag. In order to ensure a snug, waterproof fit, cut holes in the plastic slightly smaller than the lens and the viewfinder eyepiece; you will find that the controls may be easily manipulated through the polyethylene. Store memory cards in a protective case while on the site. Keep camera bags closed or encased in plastic, as well.

A commercial protective camera shroud made by Kata. A less durable, but quite useful substitute can be made from a sturdy plastic bag and a couple of elastic bands.

A number of hazards exist on construction sites. If the camera must be placed on a tripod, choose a position that is stable (the edges of excavations can be unpredictable, especially when wet) and well out of the path of machinery or busy laborers. It is easy to become absorbed in the photographic process, so make a conscious effort to stay alert to the surroundings. Keep an ear open for invisible hazards such as workers drilling through nearby walls or ceilings. Watch your step; empty stairwells may be hidden or poorly covered and there may be dangerous obstacles on the floor. Wear a hardhat and proper protective footwear. Cement dust is carcinogenic, so a filter mask is not excessive wherever concrete is being mixed, drilled, or cut up. After leaving a construction area, use a soft brush, compressed air, or a vacuum to dust off your equipment inside and out.

Find out who the construction foreman is on large projects and inform him or her whenever you are on the site. You will be advised of any dangerous locations or procedures, such as blasting or welding, and the construction workers will be informed of your presence.

9–6 PHOTOGRAPHY FROM THE AIR

Taking to the air in small planes and helicopters is a high-tech response to an old problem: unique viewpoints are very desirable, but only so much can be done from the surface of the planet. To find a photo-savvy pilot, call your local TV news media and find out whom they use to cover local stories. Small planes are relatively cheap to hire, about $100–$250 per hour. They are usually restricted to altitudes above 2,000 feet in urban areas and must always

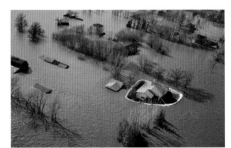

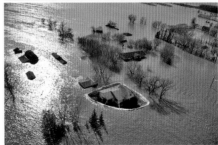

Helicopters offer a wonderfully stable platform for aerial photography. Even from this unique venue, the consequences of slight shifts in point of view can render significant changes in an image. Here, movement of only a few degrees added dramatic highlights when the reflections of the sun became visible in the floodwaters encroaching on this Manitoba farmhouse.

be moving to stay aloft, hence vibration and motion are problems. Nevertheless, good work can be done from a small plane with a patient pilot.

The technically superior solution for aerial work is a heli-copter, which is unbelievably maneuverable and can hover in one position in the sky. Helicopters are also generally allowed to fly lower than small planes, provided a flight plan is filed in advance. A helicopter costs about $400–$1,500 per hour, depending on the size of the machine.

Whatever method you use to get aloft, familiarize your-self with the mechanical limitations of the aircraft well ahead of time. Some cooperative outfits will remove doors or windows for a clearer view, in which case you will have to wear a safety harness. Test out a variety of positions and postures before the flight so that you will know how to use window or door openings to best advantage.

Time and space are limited inside an aircraft, so compact DSLR systems are useful. Since vibration and movement diminish sharpness, open the lens aperture wide and select a high ISO set-ting to permit the fastest shutter speed possible—consider 1/500 sec a minimum. As the camera and the subject will always be sepa-rated by a photographically significant distance, focus can be fixed at infinity and perspective control disappears as an issue. Turn off auto-focus and use tape to fix the focus ring at infinity. Automatic bracketing and image stabilization reduces response time to the quickly changing vistas below.

9–7 FILTERS

Optical filters can clarify or enhance images that might other-wise be confusing, inaccurate, or dull. They work by altering light and their effects range from the sublime to the ridiculous. All fil-ters fit into a few general categories. Color-contrast filters are used to increase or decrease the intensity of one particular color in black-and-white photography. Color-conversion filters are spe-cifically designed to allow fairly accurate color rendition when shooting under non-standard light sources. Color-balancing (CB) filters are used to regain neutral color rendition under ambient

NIK Color Efex offers a digital polarizer filter that mimics the effect of a conventional polarizer by detecting and darkening areas of blue sky in a digital photo.

On the left, the original image without polarization. On the right, the same scene shot with a conventional Polarizer filter in place. In the center, the image as processed by Nik's Color Efex software polarizer. The result lacks the penetration through the glass achieved by the real polarizer, but is free of the odd color effects induced by the optical polarizer in the glass flags on the right. Blue tones in both images are darker and more saturated. Optical polarizers are powerful tools that need to be deployed with care, while software polarizers, though useful, do not go quite the full distance.

conditions that vary noticeably toward warm or cool tonalities. Color-compensating (cc) filters are used to make fine incremental adjustments of color balance. Neutral-density (ND) filters diminish overall brightness. Polarizing filters reduce reflections and increase color saturation. There are also a host of special-purpose filters to accentuate, modify, or create distinctive optical effects. The control offered by the filtration process sets up a creative paradox, since filters can be chosen to produce either an accurate or an inaccurate representation. A wide range of interesting possibilities exists between these two extremes.

Today image-manipulation software offers virtual electronic filters that duplicate the optical effects of physical filters. NIK Color Efex Pro (http://www.nikmultimedia.com/) is one of several such programs. Several virtual color filters are built into Photoshop under the Image menu (Adjust : Photo Filter).

As filter effects are easy to implement electronically, the only filter I still carry is a polarizer. Many materials impart polarizing effects to transmitted or reflected light. Non-polarized light passing through the atmosphere is partly polarized by water molecules suspended in the air, and non-polarized light becomes partly polarized when it strikes glass. That is why a polarizing filter can sometimes reduce glare from windows and darken parts of the sky. Similarly, a polarizer can enhance color saturation by attenuating reflections off leaves, tile, concrete, masonry, metal, and even finished wood. Because polarization is a physical alteration of the image-forming light, the effects are difficult or impossible to duplicate electronically. The image information that is revealed whenever a polarizer blocks reflections from glass or water, for example, simply does not exist in a non-polarized image.

A neutral-density tonal gradient created in Photoshop mimics the effect of an optical neutral-density graduated filter to enhance this shot of a Hong Kong skyscraper.

9–8 PRACTICAL CONSIDERATIONS

The previous chapters provide a good technical foundation for undertaking a variety of architectural photography, but before launching into any new project, be certain to gather all the necessary information. Asking and answering the following questions will establish a working template for the creation of specific architectural images:

• What is the purpose of the photography, i.e. how will it be used?

• When is the photo required?

• What is the state of completion of the building?

• Is the landscaping in place?

• Is the building occupied?

• What is the orientation and texture of the main facade?

• How many different views are required?

• Are architectural details and embellishments to be photographed separately?

• Can furnishings and artwork be moved around during photography?

• Is access to the site restricted to any particular time of day?

• Is access to the site restricted by nearby structures?

• Are there special features that the client wishes to highlight or to hide?

• Is the client willing to arrange access, security, and site clean-up/preparation?

• Will the client attend the shoot?

• For out-of-town jobs, how will time lost to bad weather be dealt with?

• Who is the end-user: the architect, the architect's client, or a magazine editor?

• Who will evaluate the work and how will any costs for reshooting be handled?

• Who will own/store the negatives after the job is done?

• What is the budget, and who is to be billed?

• Will the client attend a pre-shooting walk-through?

10 AFTER THE SHOOT

A photo project is not complete until reproducible images reach the hands of the end-user. I rarely make prints for my clients and only occasionally supply images on disk. The bulk of my work is delivered electronically over the Internet. You can use a dial-up connection for this purpose, but it will be very, very slow-going. I recommend some sort of high-speed connection.

10–1 HIGH-SPEED FILE TRANSFER

When you need to send only a handful of images, email is the easiest option. Most of my files are about 50 MB without cropping—sufficient for reproduction in even the most critical of magazines. 50 MB is too much data to email, so I compress the TIFF into a level-8 JPEG in Photoshop, which typically results in a 3–4 MB file. Most email accounts will accept attachments of about 10 MB, so if I need to deliver a number of files I will send them three at a time.

If the end user requires TIFF files, using an FTP server (short for File Transfer Protocol) is the easiest way to move large files between computers linked through the Internet. To use FTP to receive large files, you will need an account on an FTP server. If you have an existing email account or a website, your Internet provider may be able to help. If not, there are many suppliers out there. To upload files you access the server with an FTP address, username, and password. You will also need FTP software such as Fetch (for Mac users), which can be downloaded for free from http://fetchsoftworks.com or WS_FTP (for Windows users), which can be downloaded from http://www.ftpplanet.com. Even with a fast Internet connection it takes some time to upload or download large files. On a high-speed cable connection a 50-MB TIFF requires about five minutes to upload.

Fetch is an FTP software for the Mac, with which large files can be transferred from computer to computer.

10–2 PRINTING OPTIONS

CONVENTIONAL PRE-PRESS

The photomechanical reproduction of continuous-tone images begins with the creation of a half-tone. A mechanical printing press cannot directly reproduce graduated densities the way film, photographic paper, or a computer screen can. Instead, all grayscale values are printed as collections of discrete dots of ink. Small dots spaced far apart appear to the naked eye as a light tone, while larger dots, spaced closer together appear to be a dark tone. With the aid of a magnifier, these dots, or half-tones, are clearly visible in any printed material. The degree of resolution in a printed image is dependent on the size of the dots, which, in turn, is dependent on the quality of the paper. Coarse, absorbent papers such as newsprint cause the dots of ink to spread and merge

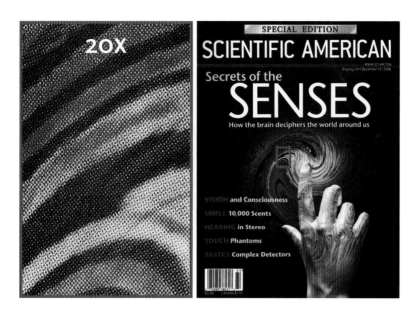

with one another unless they are spaced well apart. That is why photographs in newspapers appear soft and lacking in detail. Fine-grained coated papers allow the use of very tiny, closely spaced dots that render detail more clearly.

The traditional photo-mechanical process of producing half-tones requires a contact printer or a precision process camera. In either case, a sheet of high-contrast copy-film is sandwiched together with a glass or plastic screen ruled with very fine lines. The spacing of the lines determines the size of the dots. A coarse screen suitable for newsprint might have 45–80 lines per inch, while a screen for fine-art reproduction has up to 300 lines per inch.

ELECTRONIC PRE-PRESS

Today half-tones are generated with a computer, and the screens exist only as software. Electronic pre-press has proven to be markedly superior to the old opto-mechanical methods because it eliminates mechanical defects such as dust marks, scratches, or fingerprints, as well as optical defects caused by poor focus or misalignment of the process camera. Moreover, electronic systems

The world is composed of dots. These images of the cover of a *Scientific American* magazine illustrate how our senses are fooled by the photo-mechanical printing process: Viewed with no magnification, the text and graphics appear seamless and smooth. Magnified by a factor of 20, it becomes obvious that the seamless effect is an illusion achieved by millions of small colored dots packed onto the page.

are capable of creating half-tones that yield many more gradations of gray than traditional methods. Today direct digital printing that employs digital photography and electronic layout files, pre-press, and platemaking is rapidly becoming the standard across North America.

Decent four-color offset printing requires at least a 150 LPI (lines of dots per inch) half-tone screen; this is the typical specification for glossy magazines and journals. How does this translate to pixels or megabytes? There is a simple mathematical relationship between the number of pixels in a digital image and the minimum file size required for high-quality photo-mechanical reproduction. As a rule of thumb an image destined for half-tone reproduction should have a resolution of double the dots per inch (DPI) or pixels per inch, as that of the intended half-tone screen line frequency (LPI). Thus, a 150 LPI screen requires an original image that provides at least 300 pixels per inch. For a good reproduction of an 8x10 image you need a 2,400 x 3,000 pixel image, or a 21.6-MB file:

8 inches x 300 pixels per inch = 2,400 pixels

10 inches x 300 pixels per inch = 3,000 pixels

2,400 pixels x 3,000 pixels = 7,200,000 pixels

7,200,00 pixels x 3 bytes per pixel = 21.6 MB of image data

A DSLR camera with an 8-MP sensor generates a final image file of 24 MP, which is more than enough to create a photo-real 8x10 enlargement. As this is being written, the top-of-the-line Canon 1DS MKII generates a 48-MP native file with its 16-MP sensor. I have found this satisfies every commercial application I have encountered in my work.

DESKTOP PRINTING

There are several desktop technologies for turning digital files into impressive prints. The most accessible option is the ink-jet process, which works by projecting microscopic droplets of ink onto paper. Ink-jet resolution and color fidelity have improved to the point that a well-made print rendered on high-quality paper is indistinguishable from a traditional photographic enlargement.

The Canon i9900 desktop inkjet printer uses eight different inks to render photo-real prints that are superior to what I was able to produce in my now-dismantled chemical darkroom using conventional photographic materials. Note the blue dots on the ink cartridges shown in the inset: When printing non-critical jobs, I refill the cartridges with cheap aftermarket inks using syringes. After a refill, I block the syringe access holes with bits of reusable Plasticene modeling clay.

Required files sizes are the same as for offset printing, as described above. Color and tonal fidelity is assured by the use of several different color and black-and-white inks—as many as eight different hues in some cases. The longevity of the image is determined by the nature of the inks: Prints made with special ink-jet printers and pigment-based inks have a life expectancy of up to a hundred years. Regular ink-jet printers using dye-based inks produce prints that hold their color up to five years (more if protected by glass).

Typically, ink is supplied in small plastic cartridges. While printers are relatively cheap, these proprietary ink cartridges can be quite expensive. The ink cost per printed sheet can be reduced by up to 80 percent by buying aftermarket ink and refilling cartridges by hand. A less messy, more professional approach is a continuous bulk ink supply system, which uses large outboard tanks linked to the print head with a flat-ribbon connector composed of thin, flexible tubes, one for each color. More information and a variety of hardware is available from http://www.atlascopy.com/cfs/index.htm.

Since most of my work is delivered electronically, I do not print often. When I need to supply a hardcopy, I rely on a 13-inch-wide Canon i9900. This unit employs eight different inks—black, magenta, photo-magenta, photo-cyan, cyan, yellow, red, and green—to generate very rich, sharp prints. The lighter photo-cyan and photo-magenta colors ensure that delicate highlight details are faithfully rendered.

DESKTOP COLOR

The color accuracy of the desktop printing process depends on a number of variables. There is inevitably a basic mismatch between printed photographs and images viewed on a screen, since monitors and printers have different ways of reproducing color; monitors use additive RGB color while printers use the subtractive CMYK process. Color contrast and saturation on the printed page cannot match the range of luminosity provided by glowing chemicals on an LCD display. Printers layer ink and overlap pixels differently than scan lines and chemical phosphors. And of course, different

printers, different inks, and different papers all reproduce color differently. Calibration is the key to success. Since the process of image control depends on a series of on-screen evaluations, the first step is to calibrate the monitor. Next make sure the printer is being managed by an up-to-date driver. (Drivers are updated periodically and available for free download from the manufacturer's websites.) You can make a visual color calibration with the help of software controls within the driver, but this is crude compared to true hardware calibration. Commercial color management hardware provided by GreytagMacBeth, Eye-One, or Monaco Systems creates custom ICC profiles specific to particular combinations of monitors, printers, papers, and inks. The time, money, and frustration saved are well worth the investment in hardware calibration.

10–3 GETTING PUBLISHED

Before submitting a proposal to a magazine, make sure to study back issues to get a clear idea of a given publication's editorial rationale. Craft your proposal carefully to fit the magazine's program. Always send a query letter before submitting a comprehensive body of work, in which you briefly and concisely describe your idea for an article, why the idea is right for the publication, and what you can supply to support the proposed feature. An email is easy to ignore, but people are less likely to ignore a real letter. Always make certain that the images you submit are appropriate for the text and that they are aesthetically as well as technically excellent.

Dealing with a photo editor is not a one-way proposition. If the level of work submitted is acceptable but incomplete

in some way, you can expect to be asked to supply whatever additional images are necessary. It is at this point that many amateurs and some professionals get tripped up: arguments over style, technical approach, and the value of particular images are profoundly unwelcome. Remember also that magazines work to tight production schedules. You must respect deadlines if you want to be taken seriously. Allow sufficient time to produce and deliver whatever photographs are required. If you keep your promises, your next proposal will meet a warmer reception.

Always gather a selection of strong details when photographing a project for publication. Editors and art directors like bold detail images because they are useful for both cover art and interior layouts.

TECHNICAL REQUIREMENTS FOR PUBLICATION

Prints, transparencies, or disks should be clearly labeled. Include your name and contact information as well as a date and the title of the project. TIFF is the standard file format for publication. Minimum image resolution for publication is 8.5 by 11 inches at 300 DPI, or 25 MB, but a larger file size is usually better. At 300 DPI, an 11-by-17-inch two-page spread requires 50 MB of data.

If you do not have access to a digital camera capable of generating a 50-MB native file, you can revert to sending in 4x5 transparencies made from your digital files instead. Many service bureaus and color labs are capable of producing very good transparencies from high-quality digital images that are smaller than 50 MB. If your original work is meticulous, and if you hold the lab to a high standard, the results will be publishable.

WHAT TO SEND

There are professional benefits that accrue from publication, so you should make sure that whatever is published will be a positive

representation of your work. Shoot widely so that you can submit a generous mixture of elevations, perspective views, contextual views, medium views, and details. Include a range of light and sky conditions. But since editors do not appreciate having to wade through dozens of images, be sure to ruthlessly edit your work. Aim for a shooting ratio of 30:1—i.e. expect thirty mediocre shots for each good one—and get rid of the outtakes as soon as possible.

Even in the twenty-first century photo editors usually prefer evaluating proofs on paper rather than having to deal with a folder full of computer files. Your initial submission should consist of easily readable contact sheets with no more than nine images per page; make contact sheets from digital files with Photoshop by selecting File : Automate : Contact Sheet II from the toolbar. Captions should be submitted as a list on a printed sheet, as well as in electronic form. Fill out the appropriate metadata fields for each image through File : File Info, accessible from the toolbar in Photoshop. Indicate what the image depicts, who the photographer was, when the image was made, and why it is significant.

If you are asked to make the initial submission on disk, send small but clear JPEGs rather than reams of high-resolution files. A compact, high-quality portfolio is sufficient to guarantee that your views will be considered seriously. Do not send proofs by email: email attachments take too much time to download and may clog up the recipient's mailbox.

A working group of professional photographers created the Universal Photographic Digital Imaging Guidelines (UPDIG), which "aim to clarify issues affecting accurate reproduction and management of digital image files." Anyone providing digital images for publication will find them useful. To view the UPDIG guidelines together with detailed technical recommendations on how to apply them, visit http://www.updig.org/guidelines/index.html.

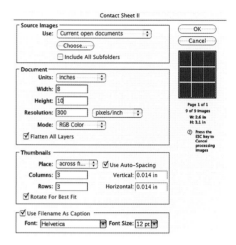

Photoshop can generate contact sheets from a file full of digital images. In the dialogue box parameters such as page size, number of images, image resolution, and type options can be fine-tuned.

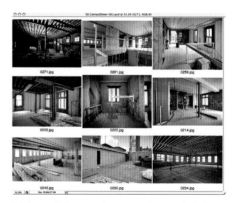

This is a typical contact sheet created automatically in Photoshop. This contact sheet carries nine images, arranged in three rows of three. Many other configurations are possible.

The minimum file size for a double-page spread in a typical 8.5-by-11-inch magazine is 50MB. On the bottom is the wide tonal-range raw file, shot on a summer evening in Las Vegas. On top, the fully Photoshopped final file as it appeared on a double page ad for Loewen Windows in *Dwell* magazine. Note the neighboring house (right of frame in raw file) has been entirely removed.

DIGITAL IMAGING RESOURCES ON THE INTERNET

GLOSSARIES OF DIGITAL IMAGING TERMS
http://www.dpreview.com/learn/?/glossary/
http://www.digitalexposure.ca/sub1.html
http://support.radioshack.com/support_tutorials/audio_video/digvid-glossary.htm

PHOTOSHOP TECHNIQUES
http://www.photoshopkillertips.com/
http://www.photoshopsupport.com/tutorials.html
http://www.photoshopcafe.com/tips.htm

GENERAL DIGITAL IMAGING INFORMATION AND PRODUCT REVIEWS
http://luminous-landscape.com/
http://www.robgalbraith.com/bins/index.asp

MAC HARDWARE AND UPGRADES
http://macgurus.com/info/storehome.php
http://macsales.com/

ADVICE ON SENSOR CLEANING / SENSOR CLEANING TOOLS
http://www.luminous-landscape.com/essays/sensor-cleaning.shtml
http://www.visibledust.com/
http://www.pbase.com/copperhill/ccd_cleaning

TOOLS FOR INCREASING SCANNER PERFORMANCE
http://www.scanhancer.com

TECHNICAL AND BUYING INFORMATION ABOUT DIGITAL CAMERAS
http://www.imaging-resource.com/TIPS/

CAMERA-MOUNTING HARDWARE AND TRIPOD HEADS
http://reallyrightstuff.com/

COMPARATIVE INFORMATION ABOUT SENSORS AND DIGITAL CAMERAS
http://www.imaging-resource.com/TIPS/BUYGD/BUYGUID.HTM

A GOOD SOURCE FOR USED PHOTO EQUIPMENT
http://www.keh.com/onlinestore/home.aspx

INFORMATION ON COMPUTER ENHANCEMENT AND PHOTOSHOP ACCELERATION
http://macgurus.com/guides/storageaccelguide.php
http://homepage.mac.com/boots911/.Public/PhotoshopAccelerationBasics2.3.pdf

GLOSSARY OF PHOTOGRAPHIC LIGHTING TERMS
http://www.lowel.com/glossary.html

GLOSSARY

ABERRATION A defect in the optical performance of a lens.

ACUTANCE A measure of image sharpness.

ADDITIVE COLOR The color model in which colors are produced by combining various percentages of red, green, and blue light.

ADOBE RGB (1998) The RGB working space created by Adobe Systems that provides a fairly large gamut of colors and is well-suited for documents that will be converted to CMYK.

ALGORITHM A rule or process used by a computer to make a decision or series of decisions. The specific process in a computer program used to solve a particular program.

ALIASING A stair-step or "jaggie" on what should be smooth lines in an image.

AMBIENT LIGHT (ALSO AVAILABLE LIGHT / EXISTING LIGHT) The light that is illuminating a scene without any additional light supplied by the photographer.

ANGLE OF INCIDENCE The angle at which light strikes a surface.

ANGLE OF VIEW (ALSO ANGLE OF ACCEPTANCE) The angle that describes the width of the field encompassed by a particular lens. A wide-angle lens has a relatively wide angle of acceptance while a telephoto lens has a relatively narrow angle of acceptance.

ANGLE OF REFLECTANCE The angle at which light bounces off a surface. For perfectly flat surfaces the angle of reflectance is always equal to the angle of incidence.

ANTI-ALIASING The process of reducing "jaggies" by smoothing edges.

ANTIREFLECTION COATING One or more thin layers of refractive material coated on the surface of a lens to minimize surface reflection.

APERTURE The adjustable diaphragm used to regulate the amount of light passing through a lens.

ARTIFACT Any visible degradation of an image caused by scanning, processing, editing or compressing the image.

AUTO-EXPOSURE BRACKETING A system that automatically makes a series of images at different exposure settings when the shutter is released.

AUTOMATIC DIAPHRAGM A diaphragm (typically in the lens of an SLR camera) that automatically closes to some preset size just before an exposure is made, and then automatically opens to its maximum size immediately after the exposure.

AUTO-EXPOSURE The process during which a modern electro-mechanically governed camera determines how long a shutter speed and how large a diaphragm setting is appropriate for a particular photographic subject.

AUTOMATIC FOCUS The process during which a modern electro-mechanically governed camera measures the distance between the camera and a photographic subject.

AUTOMATIC WHITE BALANCE (AWB) An automatic function in a digital camera that adjusts the brightest part of the scene so that it looks white.

AXIS OF POLARIZATION The orientation of the light-blocking "slots" of a polarization filter. Photographic polarizers are mounted on special rings so that the axis of polarization may be rotated to achieve the most desirable affect.

BALL-AND-SOCKET HEAD A mechanism used to attach a camera to a tripod.

BARN DOOR An accessory used on photo lamps to control the direction and width of the beam.

BARREL DISTORTION A lens aberration or defect that causes straight lines to bow outward away from the center of the image.

BEHIND-THE-LENS (BTL) METER Also known as "through-the-lens (TTL) meter." An electrical device that measures the light gathered by the taking lens.

BELLOWS The flexible accordion-like box that joins the front and back standard of a view camera.

BIT The basic unit in a binary numbering system.

BIT DEPTH The gray scale range of an individual pixel.

BLACK POINT This is the color that produces color values of 0, 0, 0 for each of the RGB components when scanned or digitized. Normally, the black point is 0 percent neutral reflectance or transmittance.

BLOOM An overflow of charge from an oversaturated pixel to the next on the sensor.

BOUNCE LIGHT A photographic technique where light from an artificial source is bounced off a reflective surface such as a white card or a light-colored wall.

BRACKETING The technique of exposing a series of images under and over the measured exposure.

BRIGHTNESS RANGE The difference in luminance between dark and light areas of the subject.

BRIGHTNESS RATIO The brightness range expressed mathematically: i.e. 128:1.

BRILLIANCE / BRIGHTNESS The intensity of light reflected from a surface. Also called luminosity.

BUS A data path in a computer used to transfer information.

BYTE Eight bits of digital information.

CABLE RELEASE A flexible remote-control trigger used to trip a shutter in order to prevent the vibration that might otherwise be induced by direct physical contact between a photographer and a tripod-mounted camera.

CALIBRATION The act of adjusting the color of one device relative to another, such as a monitor to a printer, or a scanner to a film recorder.

CHANNEL Photoshop uses the term to describe image data. A black-and-white grayscale image has one channel. An RGB color image has three channels. A CMYK color image has four channels.

CMYK Cyan, Magenta, Yellow, Black. These are the printer colors used to create color prints.

COLOR BALANCE Correct color balance implies that the colors in the scene are reproduced satisfactorily for realistic duplication.

COLOR-BALANCING FILTER / COLOR-CORRECTION FILTER An optical device that is placed in front of a photographic lens in order to change the relative brightness of certain colors in an image.

COLOR CAST Occurs when one color dominates the overall look of an image.

COLOR-COMPENSATING (CC) FILTERS Used to adjust the color balance.

COLOR GAMUT The range of colors that can be accommodated by a color-handling system.

COLOR MANAGEMENT The attempt to produce consistency in the representation of color in image files, across image capture, display, and output devices.

COLOR PROFILE A representation of the color properties of a device.

COLOR SATURATION The richness or purity of a color.

COLOR SEPARATION Conversion of RGB color information into its cyan, magenta, yellow, and black constituents.

COLOR SPACE Color spaces describe how the red, green, and blue primaries are mixed to form a given hue in the color spectrum.

COLOR TEMPERATURE A system quantifying the color spectrum of various light sources.

COMPACT FLASH CARD Flash memory card measuring 1.5 inches square. Used in digital cameras to record image files.

COMPRESSION The process of reducing the size of a digital file.

CONTRAST The difference in brightness between the lightest and darkest parts of a photographic image.

CPU Central Processing Unit. The brain of the computer.

DARK CLOTH An opaque cloth used to block light from striking the ground glass of a view camera.

DEPTH OF FIELD (DEPTH OF FOCUS) The range around a particular point of focus that is rendered as acceptably sharp in a photograph.

DIAPHRAGM An aperture of variable size that changes the amount of light transmitted by a photographic lens.

DOCUMENTARY PHOTOGRAPHY Photography that attempts to make a realistic (true-to-life) representation of a particular subject.

DIFFRACTION The bending that is induced whenever a ray of light passes a sharp edge.

DOTS PER INCH (DPI) Measure of output device resolution.

DOTS, HALFTONE Minute, symmetrical individual subdivisions of the printing surface formed by a half-tone screen.

EDGE CUT-OFF The outer limit of the image projected by a photographic lens.

EDGE FALL-OFF An optical defect in some photographic lenses (typically extreme wide-angle lenses) that renders the outer edges of the projected image as obviously darker than the center.

EXPOSURE CONTROL Refers to the process of determining the optimum camera settings for a particular subject brightness.

EXPOSURE (LIGHT) METER An electrical or electro-mechanical device that measures the brightness of light reflected by a scene or object.

F-STOP The number that expresses the size of the diaphragm opening of a photographic lens.

FALL-OFF Decrease in the intensity of light as it spreads out from the source.

FEATHERING Softening of the edge around a selection in Photoshop.

FILTER Optical devices that modify qualities of light such as color, polarization, or intensity.

FILTER FACTOR The increased exposure to compensate for light absorbed by a filter.

FIREWIRE A very fast external bus that supports data transfer rates of up to 400 MBPS.

FLARE Non-image-forming light created by defects in an optical system.

FLATTEN Combining layers and other elements of a digitally manipulated image into one.

FOCAL LENGTH The distance between the optical center of a particular lens and the point of perfect focus, when the lens is projecting the image of a very distant object.

FOCAL PLANE The plane on which the image of a subject is brought to focus behind the lens.

FOCUS Position in which rays of light from a lens converge to form a sharp image.

FRINGING Refers to a white fringe or halo that is apparent on the edges of objects in a digital image as a result of over-compression or over-sharpening.

FTP (FILE TRANSFER PROTOCOL) Used for file transfer from computer to computer across the Internet.

GAMUT The range of colors and tones a device or color space is capable of recording or reproducing.

GIGABYTE A thousand megabytes.

GRADATION / GRADIENT A smooth transition between tones.

GRAY CARD A card that reflects a known percentage of the light falling on it.

GROUND GLASS Frosted glass used as a viewing mechanism in cameras.

HALO A diffused ring of light typically formed around small, brilliant highlight areas in the subject.

HALF-TONE SCREEN A pattern of printed dots of different sizes used to simulate a continuous tone.

HISTOGRAM A graphic representation of how brightness and darkness are distributed in an image.

HOT SPOT A small (but photographically significant) spot of abnormal brightness in a photograph.

HZ Abbreviation for hertz. An international unit of frequency that equals one cycle per second.

ICC The International Color Consortium. An industry group that has endorsed a standard format for creating color profiles for digital devices.

IMAGE PROCESSING A computer discipline in which digital images are the data.

INCANDESCENT LAMP An electrical lamp in which a metal filament radiates visible light when heated in a vacuum by an electrical current.

INK JET A technology where ink droplets are propelled at the paper to form characters or graphics.

ISO A numerical description of sensitivity to light of an image-capture medium.

JAGGIES Stair-like lines that appear where there should be smooth straight lines or curves.

JPEG A standard developed by the Joint Photographic Experts Group for reducing (compressing) the amount of data required to digitally describe an image.

KELVIN COLOR TEMPERATURE A system quantifying the color spectrum of light.

KILOBYTE An amount of computer memory, disk space, or document size consisting of approximately one thousand bytes.

LARGE-FORMAT CAMERA Any camera that is intended for use with film 4x5 inches or larger.

LASSO Image-editing tool used to select areas of an image for moving or cropping in Photoshop.

LATITUDE The degree by which exposure can be varied and still produce an acceptable image.

LCD SCREEN Display screen found on digital cameras that allows previewing or reviewing of images.

LPI Line Per Inch. A measure of resolution, usually screen frequency in halftone.

LENS SHADE A device that is mounted on the front of a photographic lens in order to block any extraneous non-image-forming light from reaching the front surface of the lens.

LUMINOSITY The brightness of either a light source or a reflective surface.

MAGIC WAND This selection tool in Photoshop chooses portions of an image based on color.

MEGAPIXELS One million pixels.

MEGABYTE A unit of measure of stored data equaling approximately 1,000,000 bytes.

METADATA Data about data, or information about a digital image.

MONITOR CALIBRATION The process of correcting the color settings of a monitor.

MOVEMENTS The adjustments a view camera can make.

NEUTRAL DENSITY (ND) FILTER An optical device that is fitted in front of a photographic lens in order to reduce light transmission by a known amount without changing the color of the light.

NOISE The visible effects of electronic errors in the final image from a digital camera.

NON-LOSSY Image compression without loss of quality.

OPTICAL AXIS An imaginary line passing horizontally through the center of a compound lens system perpendicular to the image plane.

PAINTING WITH LIGHT A technique that allows a large scene to be illuminated by smoothly sweeping the beam of a light during a long exposure.

PANORAMA A broad view or a series of images stitched together to create a wide view.

PERSPECTIVE-CONTROL (PC) LENS A specially designed lens that mimics view camera perspective-control movements.

PERSPECTIVE DISTORTION The unnatural appearance of objects in photographs made without the use of perspective control.

PDF Portable Document Format. A file format that contains all the elements of a printed document.

PHOSPHOR The chemical substance that glows when electrically charged.

PHOTON A quantum of radiant energy. The smallest "package" of light found in nature.

PICTORIAL PHOTOGRAPHY A romantic, highly stylized type of landscape photography.

PINCUSHION DISTORTION A lens aberration that causes straight lines to bow inward toward the center of the image.

PIXEL From Picture Element. A single point in a graphic image.

PLANE OF FOCUS A two-dimensional plane that describes the location of the sharply focused image of a photographic subject.

PLUG-IN Third-party software that can be integrated into Photoshop to expand functionality.

PNG Portable Network Graphics (PNG) format is used for loss-less compressing and displaying images on the World Wide Web.

POINT-AND-SHOOT An easy-to-use camera with a minimum of user controls.

POLARIZING FILTER Polarizing filters transmit light waves that vibrate in a single direction.

PREVISUALIZATION The process of determining the properties of a photographic image before an exposure is made.

RAW IMAGE FORMAT A file that contains all the image data recorded by a digital sensor.

RECYCLING TIME The time it takes a flash unit to recharge between firings.

RESOLUTION Refers to the sharpness and clarity of an image.

SATURATION The vividness or purity of a color.

SCRATCH DISK A virtual memory scheme that uses hard-disk space as a substitution for RAM.

SELECTION TOOL A Photoshop function that delineates a specific image area.

SHARPENING The enhancing of edge detail.

SHARPNESS The degree of image clarity in terms of focus and contrast.

SHUTTER A mechanical or electro-mechanical device that opens and closes a light-tight barrier for a predetermined length of time so as to allow a controlled exposure of light.

SINGLE-LENS REFLEX (SLR) A camera design incorporating a mirror and a prism that allows the photographer to see in the viewfinder whatever the taking lens sees.

SPECULARITY The relative size of a light source to the object being photographed. A source that is significantly smaller than the subject is said to be highly specular.

SOFTBOX A light modification device for electronic flash and halogen lights, made of nylon fabric, black on the outside, silver on the inside, with a translucent diffuser on the front. Easily collapsible. Comes in various sizes. Provides a directional source of soft light.

SUBTRACTIVE COLOR Combining cyan, magenta, and yellow to create black.

SYNC CORD A cable connecting a flash unit with a camera so that the two can be synchronized.

TELEPHOTO LENS A photographic lens with a relatively narrow angle of acceptance.

TERABYTE Approximately 1,000,000,000,000 bytes of information.

THUMBNAIL A small, low-resolution version of a larger image file.

TIFF Tagged-Image File Format (TIFF). A popular loss-less file format supported by the majority of image-editing programs running on a variety of computer platforms.

TONAL VALUES Various shades of gray between the extremes of black and white.

UNSHARP MASKING A digital process in Photoshop by which the apparent detail of an image is increased.

USB Universal Serial Bus. A simplified way to attach computer peripherals.

VAPOR LAMP A lamp containing a gas that glows when an electric current passes through it.

VIEW CAMERA A camera design that allows the photographer to manipulate various optical parameters.

WHITE BALANCE Adjustment of the relative brightness of the red, green, and blue components so that the brightest object in an image appears as white.

WS (Watts per second) The unit of measurement for the electrical energy stored in an electronic flash.

WIDE-ANGLE DISTORTION The unnatural appearance of foreground objects in a photograph made with a wide-angle lens.

WIDE-ANGLE LENS A photographic lens with a wide field of view.

INDEX